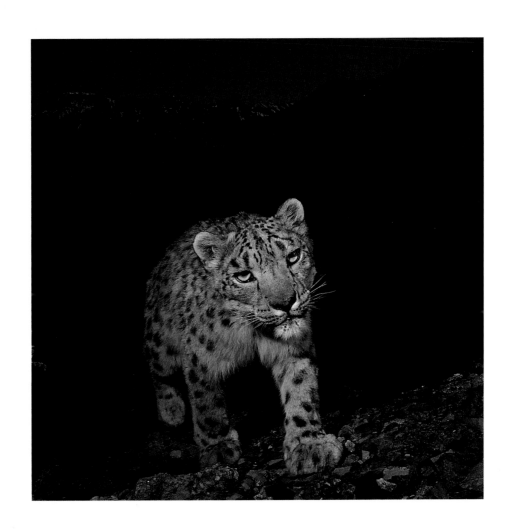

Wildlife Photographer of the Year Portfolio 18

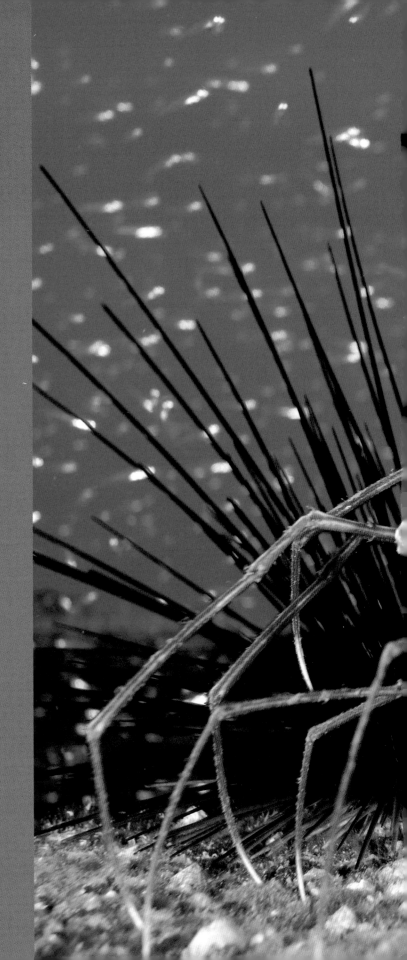

Wildlife
Photographer
of the Year
Portfolio 18

BOOKS

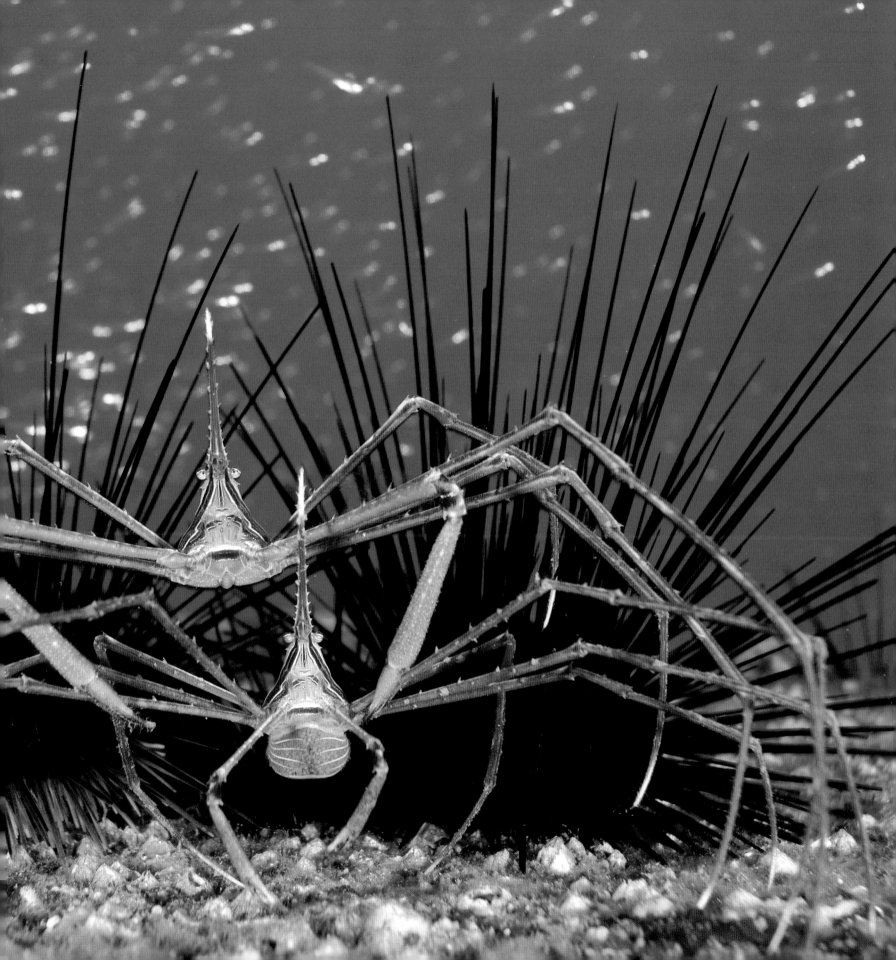

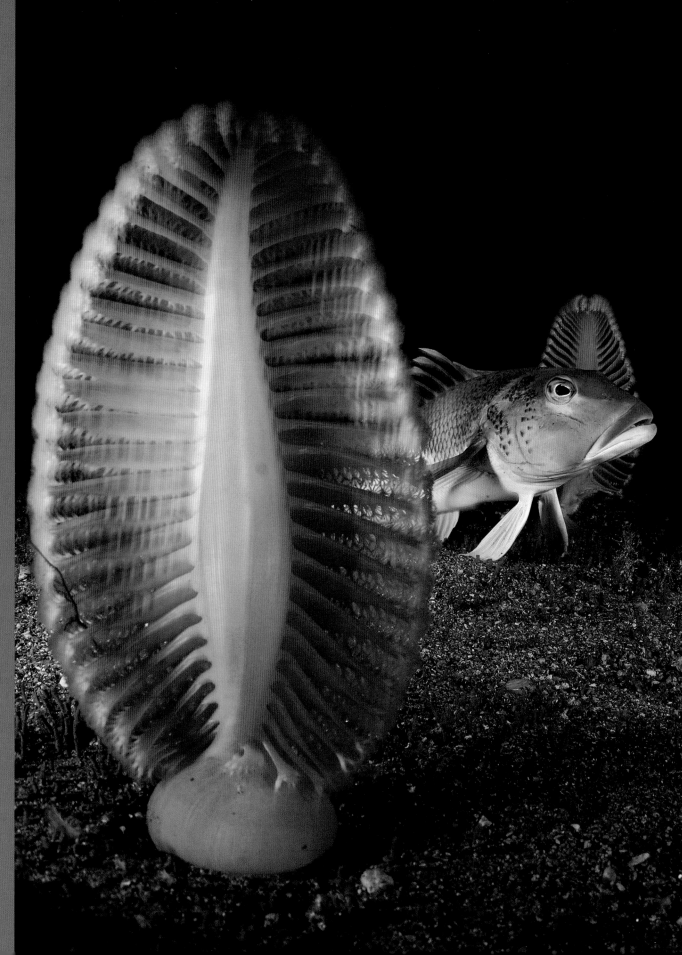

Published in 2008 by BBC Books,
an imprint of Ebury Publishing.
A Random House Group Company

Compilation and text
© Woodlands Books 2008
Photographs © the individual
photographers 2008

10 9 8 7 6 5 4 3 2 1

The Random House Group Limited
Reg. No. 954009
Addresses for companies within the
Random House Group can be found
at www.randomhouse.co.uk

A CIP catalogue record for this book
is available from the British Library

ISBN 978 1 846 07581 0

Commissioning Editors
Shirley Patton and
Christopher Tinker
Managing Editor
Rosamund Kidman Cox
Designer Bobby&Co Design
Caption writers
Rachel Ashton and
Tamsin Constable
Production David Brimble
Competition Editor
Gemma Webster

The Random House Group Limited
supports The Forest Stewardship
Council (FSC), the leading international
forest certification organisation.
All our titles printed on FSC certified
paper carry the FSC logo. Our paper
procurement policy can be found at
www.rbooks.co.uk/environment

Colour origination by
Dot Gradations, Wickford, England
Printed and bound in Italy by
Printer Trento SrL

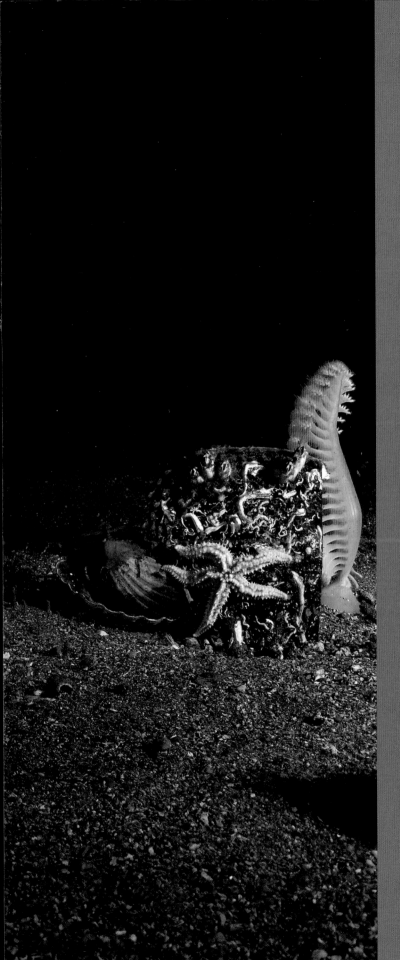

Contents

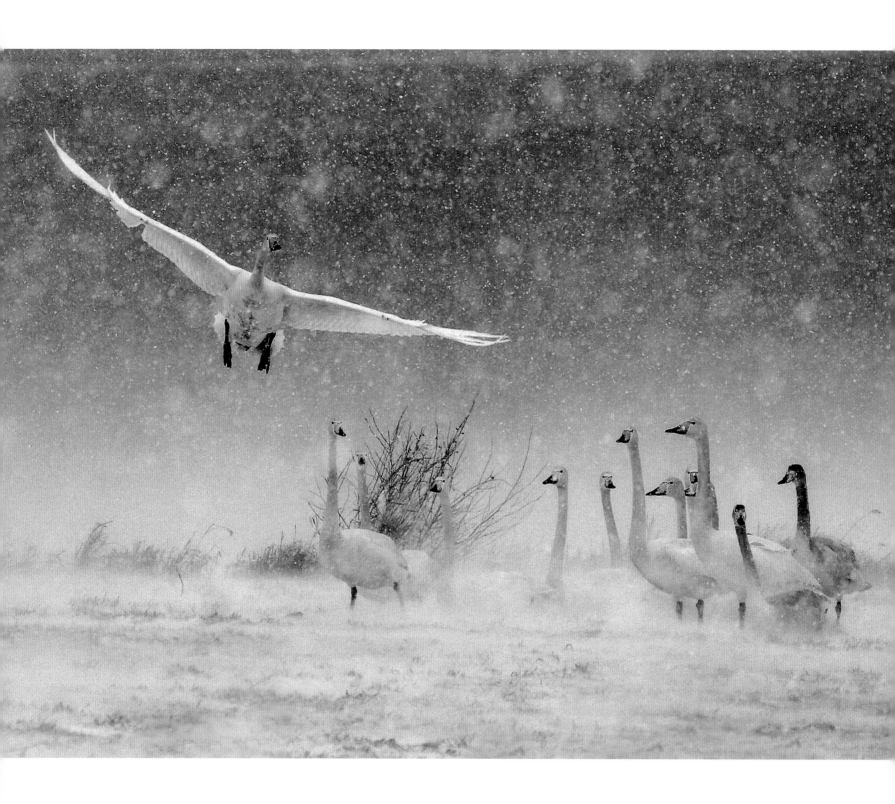

Foreword

This collection of photographs is truly a celebration of nature and wild places. You will find animals and plants you may never see and regions of the world that you may never be able to visit. But becoming aware of them or seeing them in a new light is the start of a visual relationship with the wild – one that grows stronger the more you look at nature pictures. It also becomes a two-way relationship if we lend our voices, votes and actions to ensure that such wild creatures and wild places continue to exist.

What I love about so many of these pictures is that the subjects are seen through fresh eyes and a developing awareness of the natural world. When I came to London to judge this year's images, I expected to see great nature photography from around the world, by great photographers both famous and as yet little known. What I hoped for was surprise and inspiration. And I got it, right from the start, from the youngest entrants. Indeed, I would have been rewarded enough to see only the entries from these talented young people – pictures that I'll never forget.

Friend and colleague David Doubilet summed up for me the kind of photography worth doing. I paraphrase: 'Man, you shoot two kinds of images – things that people have never seen and things they have seen in a way that makes them new again.' In this book there are significant examples of both. Subjects I believed had been totally over-photographed I saw presented in new ways and from fresh angles – Yongkang Zhu's swans opposite, for example. I also saw how improved technology and artistic vision can combine to give us seldom-seen images of animals relaxed and in their environment.

It's a very exciting time to be a photographer. And central to this is the digital camera. Photographs in the digital age now have new tools and old controls. We have instant feedback on our images – a great advantage, allowing us to learn as we shoot. But we can also participate in the processing – work in our own digital darkroom. Indeed, the ability to be involved once again in image development is a major discussion point among photographers everywhere.

I think there is no doubt that digital photography has changed the way we shoot pictures, interpret the outcome and share the end result. Better remote systems, automatic focus and metering and more sensitive media also expand what we can do. The images here show a bright future for nature photography, and my hope is that this future helps reconnect us with the wild and inspires actions that show our commitment to safeguarding it.

Flip Nicklin, photographer and judge

The competition

The pictures gathered here are prize-winning or commended images from this year's Wildlife Photographer of the Year competition – *the* international showcase for the very best photography featuring natural subjects. It's owned by two UK institutions that pride themselves on revealing and championing the diversity of life on Earth: the Natural History Museum and *BBC Wildlife Magazine*.

Being placed in this competition is something that wildlife photographers worldwide aspire to. Professionals win many of the prizes, but amateurs succeed, too. That's because the perfect picture is down to a mixture of vision, camera literacy, knowledge of nature – and luck. And such a mixture doesn't always require an armoury of equipment and global travel, as many of the pictures by young photographers reveal.

The judges, representing artists and professionals from other media as well as photography, put aesthetic criteria above all others. But at the same time, they place great emphasis on photographs taken in wild and free conditions, considering that the welfare of the subject is paramount. They are also always looking for pictures with that extra something – creative flair that takes a picture beyond just a representation of nature.

The origins of the competition go back to 1964, when the magazine was called *Animals* and there were just 3 categories and about 600 entries. It grew in stature over the years, and in 1984, *BBC Wildlife Magazine* and the Natural History Museum joined forces to create the competition as it is today, with most of the categories and awards you see in this book.

Now there are upwards of 30,000 entries (this year, more than 32,350), a major exhibition at the Natural History Museum and exhibitions touring throughout the year in the UK but also from the Americas through Europe and across to China, Japan and Australasia. The prize-winning and highly commended pictures appear in *BBC Wildlife Magazine* and publications around the globe. As a result, the photographs are now seen by millions of people.

The competition aims are
- to use its collection of inspirational photographs to make people worldwide wonder at the splendour, drama and variety of life on Earth;
- to be the world's most respected forum for wildlife photographic art, showcasing the very best photographic images of nature to a worldwide audience;
- to inspire a new generation of photographic artists to produce visionary and expressive interpretations of nature;
- to raise the status of wildlife photography into that of mainstream art.

Judges

Tom Ang
photographer and writer

Mark Carwardine
(chair) zoologist, writer and photographer

Ross Hoddinott
photographer

Phil Keevill
creative director, Kitcatt Nohr Alexander Shaw (KNAS)

Rosamund Kidman Cox
editor and writer

Jouni Klinga
photographer

Cristina Mittermeier
executive director, International League of Conservation Photographers

Flip Nicklin
photographer

Norbert Rosing
photographer

José Ruiz
photographer

Sophie Stafford
editor, *BBC Wildlife Magazine*

early-selection judges

Phil Hurst
photographer, Natural History Museum

Paul Lund
photographer, Natural History Museum

Tor McIntosh
picture researcher/editor

Wanda Sowry
picture researcher, *BBC Wildlife Magazine*

Kevin Webb
photographer, Natural History Museum

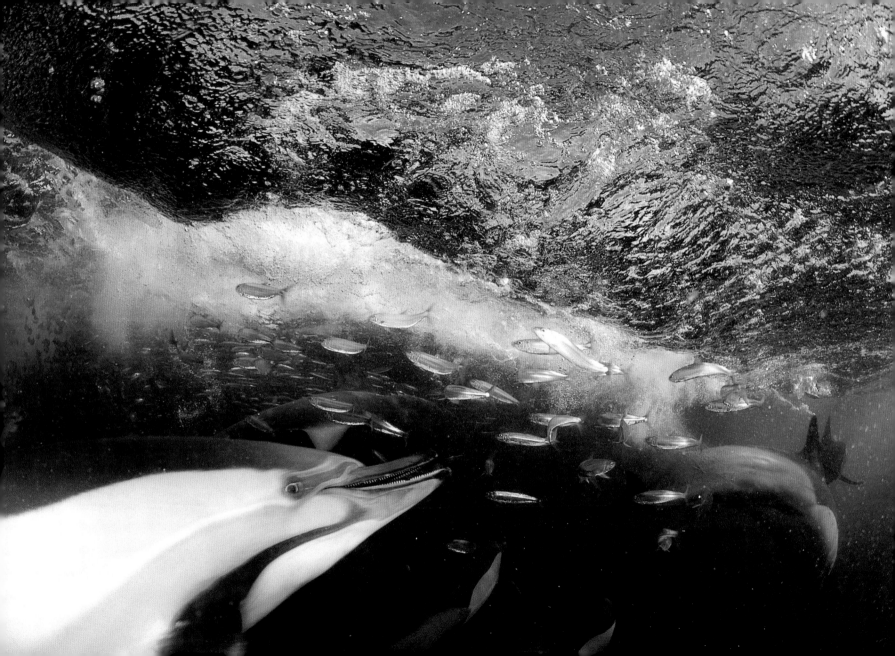

Organizers

The competition is owned by the Natural History Museum, London, and *BBC Wildlife Magazine*.

Open to visitors since 1881, the Natural History Museum looks after a world-class collection of 70 million specimens. It is also a leading scientific-research institution, with ground-breaking projects in more than 68 countries. About 300 scientists work at the museum, researching the valuable collections to better understand life on Earth, its ecosystems and the threats it faces.

Every year more than 3 million visitors, of all ages and levels of interest, are welcomed through the Museum's doors. They come to enjoy the many galleries and exhibitions, which celebrate the beauty and meaning of the natural world and encourage us to see the environment around us with new eyes.

Wildlife Photographer of the Year is one of the Museum's most successful and long-running exhibitions. Together with *BBC Wildlife Magazine*, the Museum has made it the most prestigious, innovative photographic competition of its kind and an international leader in the artistic representation of the natural world.

Last year's exhibition attracted a record 133,000 visitors before it toured venues across the UK and throughout the world. People come to see the world's best wildlife photographs and gain an insight into the diversity of the natural world – an issue at the heart of our work.

Visit www.nhm.ac.uk
for what's on at the Museum.
You can also call +44 (0)20 7942 5000,
email information@nhm.ac.uk
or write to us at: Information Enquiries,
The Natural History Museum,
Cromwell Road, London SW7 5BD.

For more than 40 years, the magazine has showcased the wonder and beauty of planet Earth, its animals and wild places – and highlighted its fragility.

By helping our community of more than 300,000 readers to understand, experience and enjoy the wildlife both close to home and abroad, we inspire them to care about the future of the natural world and take action to conserve it.

Every month, *BBC Wildlife* brings a world of wildlife to people's living rooms. We pride ourselves on our spectacular photography, and for this we rely on the photographers whose brilliance has been celebrated by the Wildlife Photographer of the Year competition since its launch in 1964.

Each issue includes page after page of beautiful photographs by the award-winning photographers, complete with the wild animals and even wilder stories behind them – and through their eyes we see the world's wildlife in all its glory.

You can take home all the winning images from Wildlife Photographer of the Year 2008 competition in our exhibition guide, free with our November issue.

Visit www.bbcwildlifemagazine.com
to find out more about *BBC Wildlife*, chat on our forum, download our podcast and show us your photos.
You can also call +44 (0)117 927 9009
or email wildlifemagazine@bbcmagazinesbristol.com

Subscribe to *BBC Wildlife Magazine*
to save 25 per cent on the shop price.
Call 0844 844 0251
or email wildlife@servicehelpline.co.uk
quoting WPOY08.

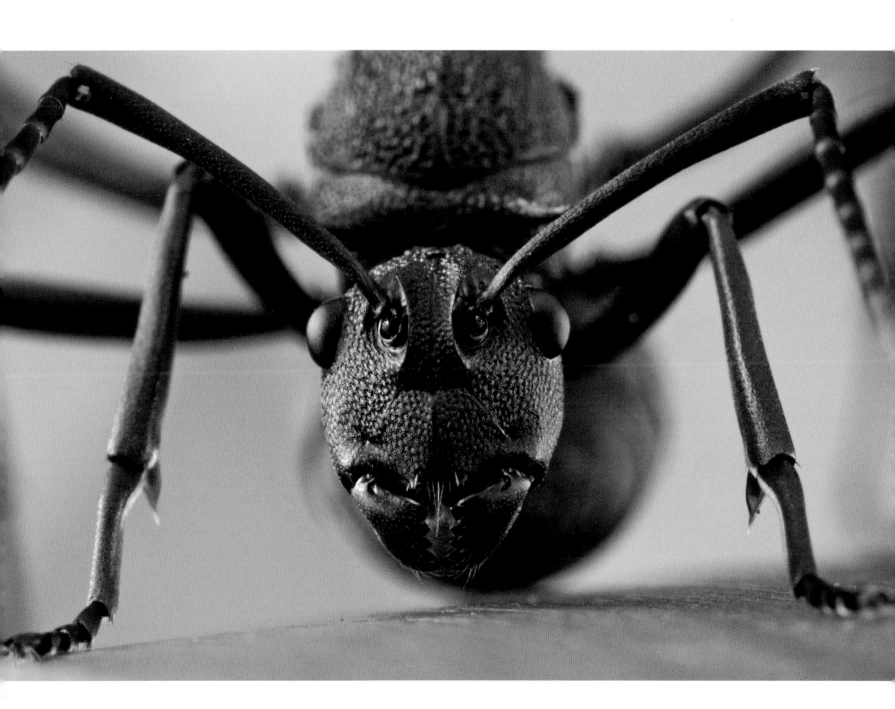

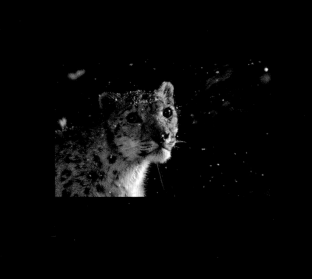

Wildlife Photographer of the Year Award

The Wildlife Photographer of the Year
Award 2008 goes to Steve Winter,
whose picture has been chosen as the
most striking and memorable of all
the entries in the competition.

Steve Winter

When growing up in Indiana in the US,
Steve dreamed of travelling the world.
He was given his first camera at the age
of seven, and from then on he set his
sights on becoming a photojournalist.
After graduating with a degree in
photography, he began working for Black Star Photo Agency,
producing stories for a range of publications including *Time*,
Audubon, *GEO* and *Stern*. Then in 1991, he began shooting
for *National Geographic*, fulfilling his dream. His stories for
the magazine have covered people, cultures, global
environmental issues and his passion, wildlife – from tigers
in Burma, the giant bears of Kamchatka and jaguars in
Amazonia to the effects of oil pollution on rainforests.

Snowstorm leopard

The snow leopard has become a symbol of both the
survival of its remote mountain habitat and the whole
relationship between humans and nature. This elusive
cat has been a holy grail for biologists, writers and
photographers. Its superb camouflage and the high
altitudes and freezing conditions where it lives mean
that very few Westerners have ever seen, let alone
photographed, one in the wild. Steve's success was
the result of total dedication and perseverance, with
the backup of an expedition to the remote Hemis
High Altitude National Park in the Himalayas.
The sheer technical challenge behind the creation
of this image meant that it took ten months before he
got the shots he wanted. The award for his picture
was, though, given because the image is, quite simply,
a strikingly beautiful and evocative portrait of a wild
creature in its element. (See also page 122.)

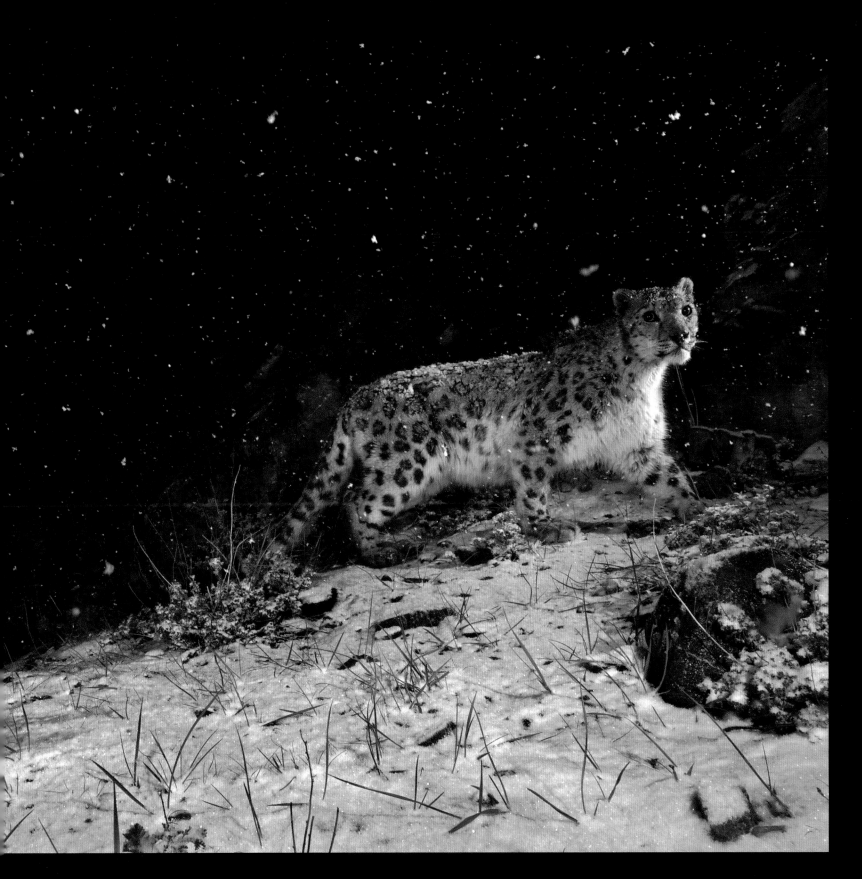

Pictures in this category should take inspiration from nature but reveal new ways of seeing natural subjects or scenes. They can be figurative, abstract or conceptual but must provoke thought or emotional reactions, whether through their beauty or imaginative interpretation.

Polar sunrise

WINNER

Miguel Lasa

UK/SPAIN

This was an image that Miguel set out to create. So many of the photographs he'd seen of polar bears around Churchill on Canada's Hudson Bay didn't convey the power of the animals or any sense of the harshness of the polar environment. Photographers flock to Churchill in the autumn because this is when the bears gather, waiting for the sea to freeze over. They are starving and by November are desperate to get out onto the ice and feed on fresh seal-meat. For ten dark, overcast days, Miguel slept in a tundra vehicle beside the bay in the Wapusk National Park, rising before the sun was up, hoping for a bear in the right position at the right time. While the bears paced the beach waiting for the ice, Miguel waited for the perfect light. Finally he got the shot he was after – a bear backlit by the first rays of sunlight.

Canon EOS 40D + Canon EF500mm f4 IS USM lens; 1/1250 sec at f4 (+2/3 compensation); ISO 400.

Ghost of a March hare

RUNNER-UP

Michel Roggo

SWITZERLAND

Michel was on an assignment to photograph beavers when the hares got to him. Walking with a warden along a creek, looking for good beaver spots, they came towards a field. 'Suddenly the warden stopped and pointed to the field,' recalls Michel. ' "What do you see?" he asked. I saw nothing. But looking through his binoculars, there was this big golden eye.' It belonged to a perfectly camouflaged brown hare. Some days later, Michel woke to a fresh blanket of snow. 'Immediately I remembered the golden eye and began thinking how I might photograph the hares hidden deep in the white snow – that wonderful golden eye in the middle of the pure white.' He went straight to the field, but by then, the day had warmed up, and so had the hares, which were chasing each other around, as mad mating March hares do – 'not easy to photograph, even with the modern high-performance digital cameras'. Editing his photographs afterwards, Michel came across this shot, which he almost deleted. 'It broke all the rules – it was out of focus, with the animal running out of the picture. But the more I looked at it, the more I realized that this was *the* picture. To me, it represents the nature of hares – bolting briefly into view and then disappearing like ghosts.'

Canon EOS 40D + Canon EF500mm f4 IS USM lens with Canon EF 1.4 II extender; 1/160 sec at f16; ISO 200.

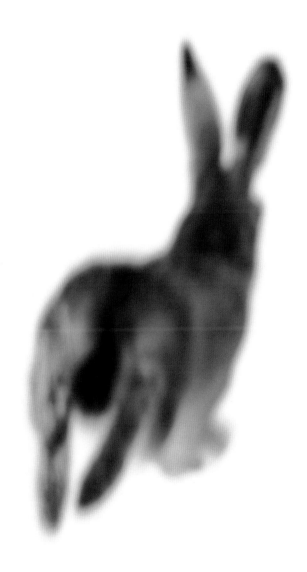

Behaviour
Birds

Birds are among the most popular subjects for photographers entering the competition. But the challenge is to take a picture with aesthetic appeal that also shows active or interesting behaviour.

Clash of eagles

WINNER

Antoni Kasprzak

POLAND

The winter in Poland had been particularly cold and snowy, making it difficult for the eagles to find prey. So when Antoni found a dead moose hit by a train, he knew it would be the ideal bait. Setting up his hide by the bait, he waited. Five hours later, an adult and an immature white-tailed eagle arrived together, and a struggle broke out. A snowstorm provided the perfect backdrop for the scene. Not surprisingly, the older, more experienced bird won, forcing the immature eagle to wait its turn for more than an hour, along with the queue of magpies and other scavengers.

Canon EOS 40D + Canon EF500mm f4 IS USM lens; 1/1000 sec at f4.5; ISO 500; tripod.

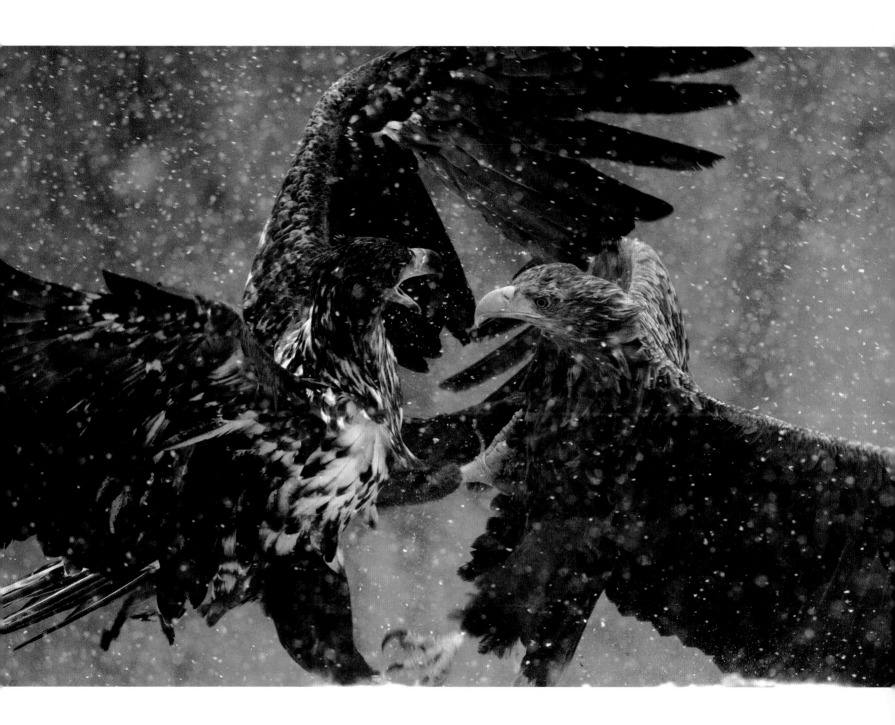

Getting stuck in

RUNNER-UP

Brian W. Matthews

UNITED KINGDOM

Brian was looking for jaguars along the Cuiabá
River in the Pantanal, Brazil, when he noticed
circling black vultures. Moving downriver to where
they had landed, he discovered the attraction:
a spectacled caiman carcass. The vultures had
already started to tuck in, going for the eyes first,
digging down through the sockets to the meat
inside. Lying on the muddy bank, eye-to-eye with
the scavengers, he remembered how 'the early
morning light was beautifully soft,' but that
'the smell was truly terrible.'

**Canon EOS-1D Mark II + Canon EF500mm IS USM lens;
1/640 sec at f4 (-1 compensation); ISO 200.**

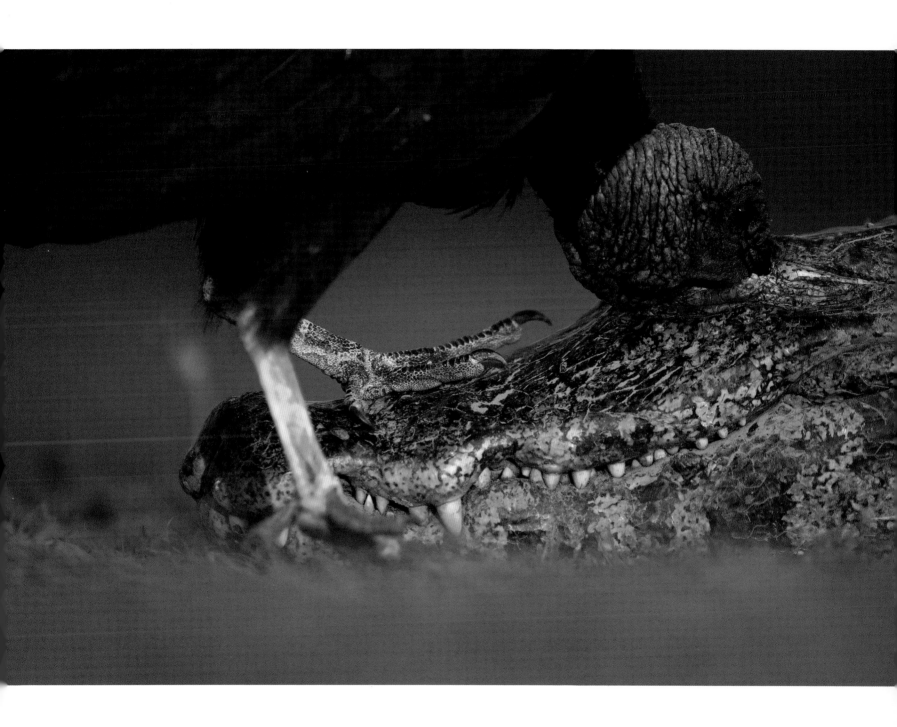

Osprey snatch

SPECIALLY COMMENDED

Paul Hobson

UNITED KINGDOM

Having grabbed a trout in its talons and almost submerged itself in the process, the osprey powers out of the water, spray exploding around it. Not only has the action been frozen at the perfect moment, with the osprey head-on and dead centre, but its eyes are also in sharp focus. To get the shot, Paul had to live in a hide overlooking a lake in Pohtiolampi, Finland, for five days, waiting for ospreys going south for the summer to stop off to feed. For four days, the wind blew in the wrong direction, and the birds dived behind the hide. Only on the last day did the wind change briefly allowing just this single shot of the osprey in the position that Paul had hoped for.

Canon EOS-1D Mark III + 300mm f2.8 lens; 1/3200 sec at f5 (-2/3 compensation); ISO 400.

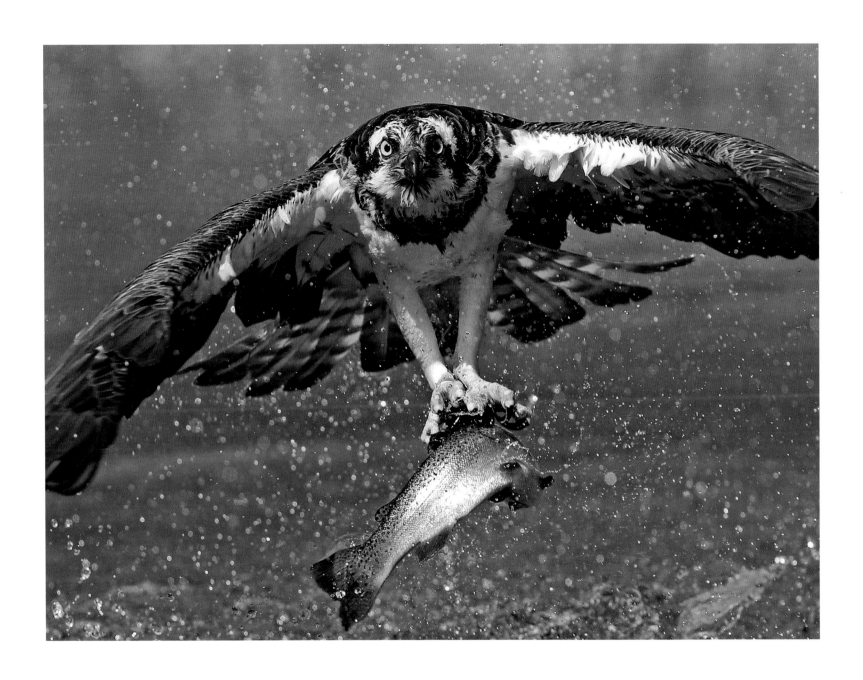

Black grouse dawn show

HIGHLY COMMENDED

Bence Máté

HUNGARY

Bence had never seen a black grouse before. As advised by friends, he arrived at the lek – an unremarkable scrubby clearing on private land in Finland – an hour before dawn. He quickly got his equipment into the tent he was using as a hide, and as soon as he stuck his lens out, the first male appeared. He was thrilled. For the next three hours, along with a handful of nonchalant female grouse, he watched four males strut, march, fluff, flutter, flounce, shimmy, sashay, 'roo-roo-roo', leap and fight to be judged as the fittest, most promising, most mateable male. 'There are places in Finland where up to 100 black grouse lek,' says Bence, 'but just seeing one would have been enough for me.' The females weren't so impressed: none of them mated.

Nikon D200 + Sigma 300-800mm f5.6 lens; 1/640 sec at f7.1; ISO 400; beanbag.

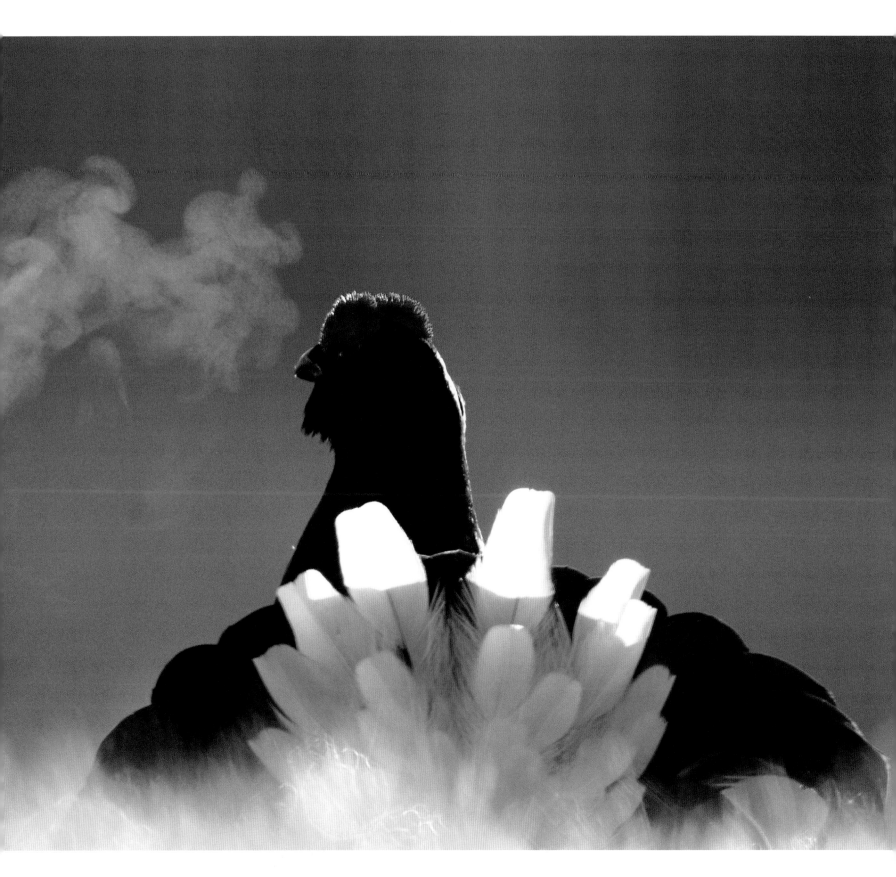

Love branch

HIGHLY COMMENDED

Andy Rouse

UNITED KINGDOM

Sex for a stick. That seemed to be the deal, Andy realized, as he spied on a pair of nest-building ospreys in a remote part of Finland. 'It's rare enough even to see ospreys mating, never mind photograph them,' he says. So to witness such intimate sexual politics was even more of a triumph. 'Every time the male offered the female a twig, she would mate with him,' said Andy. 'But if he came home with moss, she wouldn't.' To get this branch, the male performed a magnificent stunt. 'He punched into the top of a tree, one talon above the other, and snapped the branch off. As the branch fell, he swooped down, snatched it out of the air and twirled it into position for flight.' At the same time, Andy performed his own split-second actions, immortalizing the moment. The osprey then carried his prize back to his mate – and received his well-earned reward.

Canon EOS-1Ds Mark II + 300mm f2.8 IS lens; 1/250 sec at f4; ISO 400; Gitzo 1548 tripod + Wimberley head.

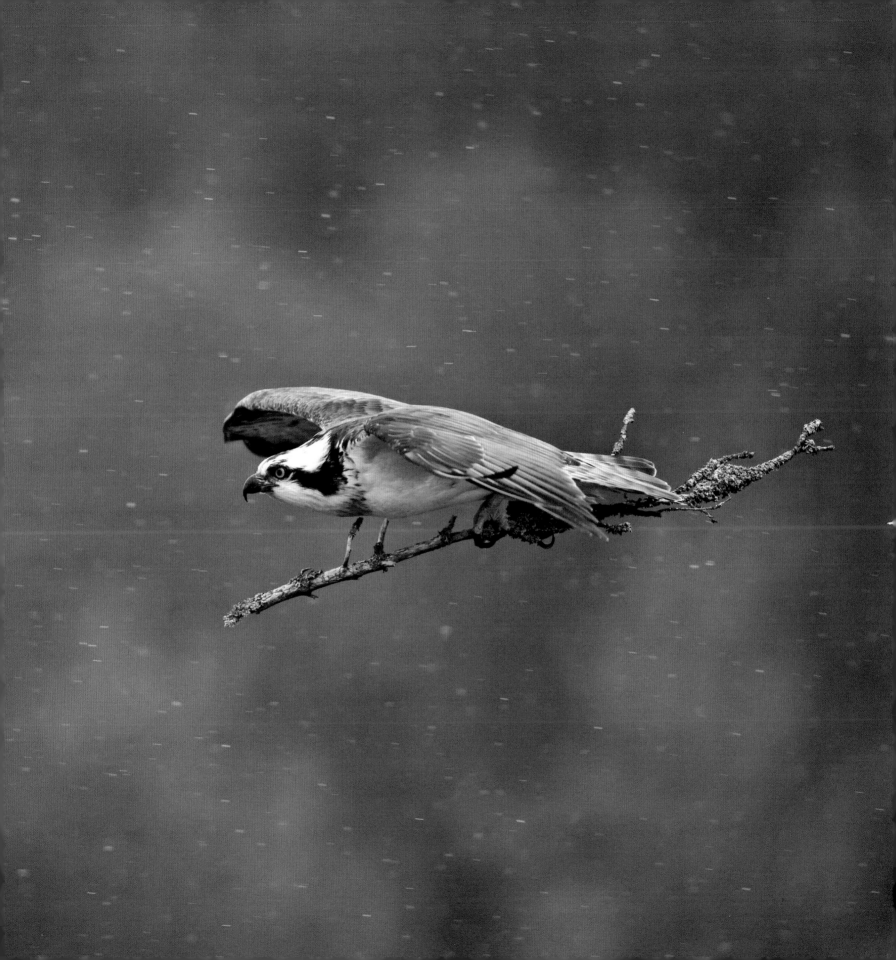

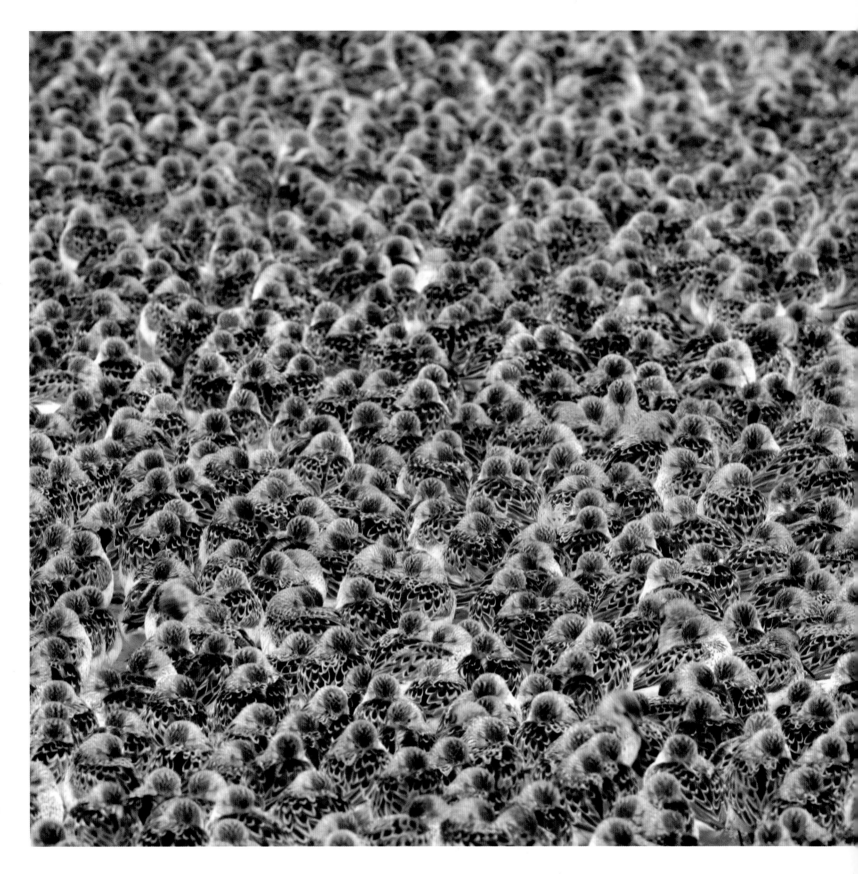

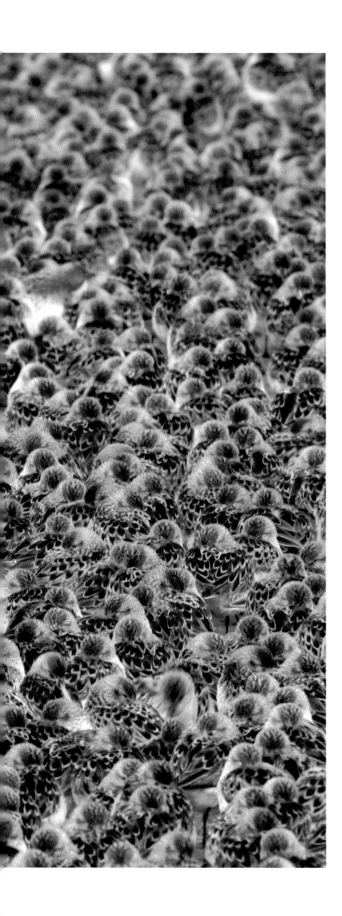

Sandpiper congregation

HIGHLY COMMENDED

Arthur Morris

USA

Having noted the average peak time for numbers of migrating western sandpipers, Arthur flew in early May to the Alaskan fishing town of Cordova, when the flocks should have been at their peak. There would be tens of thousands of birds to photograph en route to their northern breeding grounds. But Arthur was too late. He was told he had missed the peak of the migration by a week and that only a few birds were left. Then a friend said he might find a flock on a sandbar very near town. With low expectations but aiming to get some close-up shots, Arthur went down to the beach. And there in full view was a snoozing congregation of 6000 or so western sandpipers snuggled together, their subtle colours enhanced by the flat light of an overcast sky.

Canon EOS-1D Mark II + Canon EF500mm f4 IS USM lens; 1/60 sec at f22 (+1/3 compensation) ; ISO 400; Gitzo 1325 CF tripod + Wimberley head.

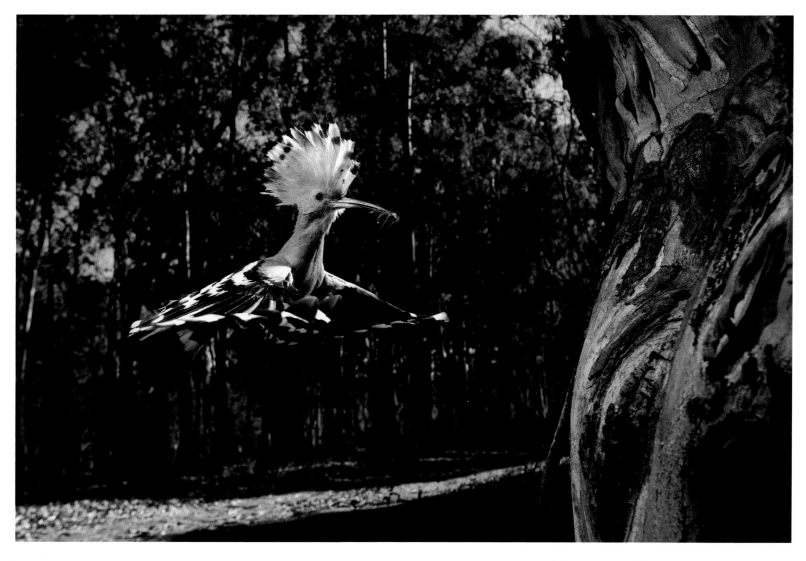

Hoopoe gift

HIGHLY COMMENDED

Ramón Navarro

SPAIN

Hoopoes are Ramon's favourite subjects. 'I like everything about them,' he says, even their noxious defences – emitting a foul smell if threatened and, in the case of the chicks, squirting liquid faeces. In the eucalyptus grove near his home in Seville, Spain, Ramon used a remote set-up and a wide-angle lens to capture the environment as well as the action. Here the male is flying to the nest-hole, crest spread high, with yet more provisions for his family.

Canon EOS-Ds Mark II + Canon 17-40mm f4 lens; 1/250 sec at f11; ISO 200; three high-speed flash units in manual mode at 1/16; infrared beam.

Starling genie

HIGHLY COMMENDED

Barış Koca

TURKEY

At Lake Mogan, near Ankara in Turkey, the photographer tried over and over again, day after freezing day, to capture the amazing shape-shifting of the flocks of starlings coming in to roost. But none of his attempts did the spectacle justice. Then, one weekend, something different happened. The lake was frozen, and so he was able to stand facing the reeds with the sun behind him. As usual, at about 5pm, huge flocks of starlings wheeled in over the horizon to merge into dense super-flocks, providing half an hour of incredible aerobatic routines. Then, as the sun set, the birds pirouetted into the spotlight of its rays, and the perfect picture was created. As they descended, their wings sounded like soft clapping. It was 'so relaxing' that he stopped taking photographs and just listened. Then the starlings twittered down into the reeds, and the curtain of darkness fell.

Canon EOS 30D + Sigma 18-200mm f3.5-6.3 DC OS lens at 18mm; 1/320 sec at f9; ISO 200.

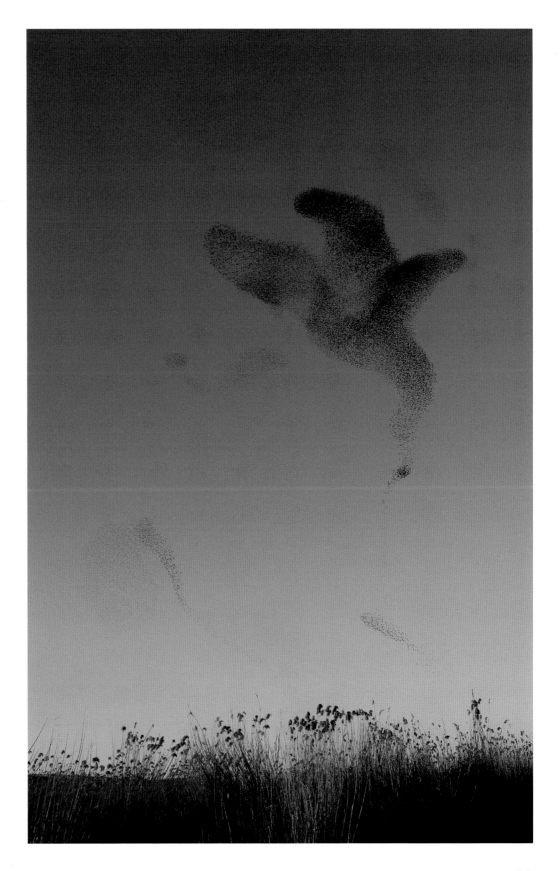

Behaviour
Mammals

The pictures in this category are selected to show action and interest value as much as aesthetic appeal.

Frodo's prize

WINNER

Cyril Ruoso

FRANCE

Ear-splitting screams rang through the forest. The chimpanzees sounded almost hysterical with excitement. Cyril struggled through the dense undergrowth and found himself watching a rare and gory scene. Frodo, now 31 and going grey, may have lost the alpha status he held for many years, but he is still the biggest, most powerful and most skilled hunter of the Kasekela chimps in Tanzania's Gombe National Park. Usually, the chimps go for monkeys. This time Frodo, egged on by the frantic screeches of the rest of the group, had caught something much more unusual: a bushpig. There had clearly been a frenzied tug-of-war, because the bushpig's body was ripped in two. And that was all the sharing Frodo was prepared to do. Ignoring the begging of the other chimpanzees, he tucked into the rare (in both senses of the word) feast.

Canon EOS-1D Mark III + Canon EF400mm f2.8 IS USM lens; 1/320 sec at f2.8; ISO 250.
With logistical support from the Jane Goodall Institute.

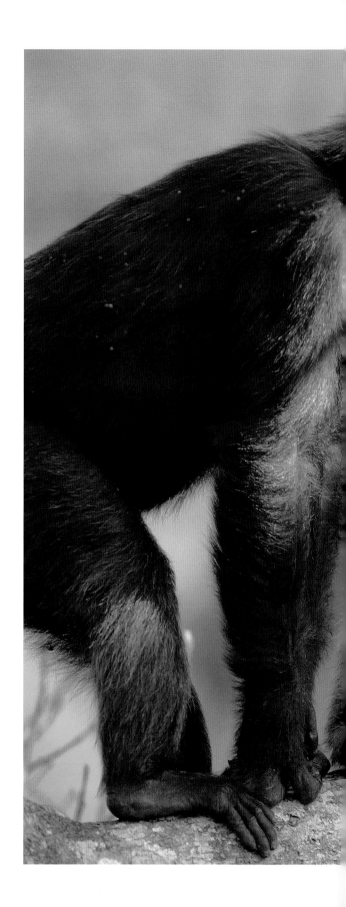

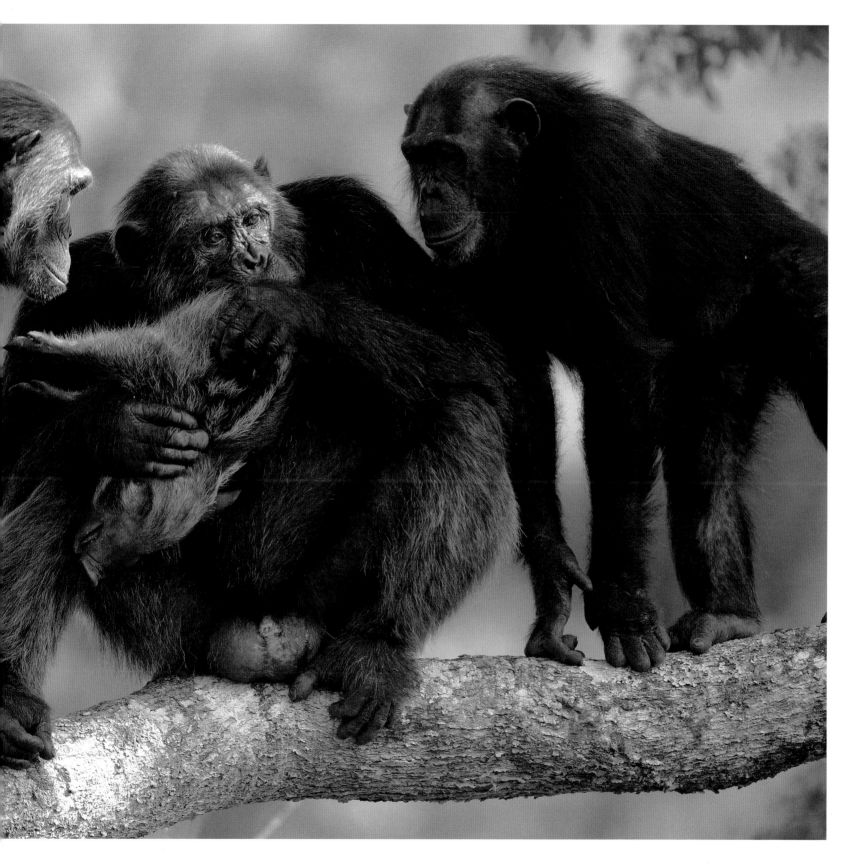

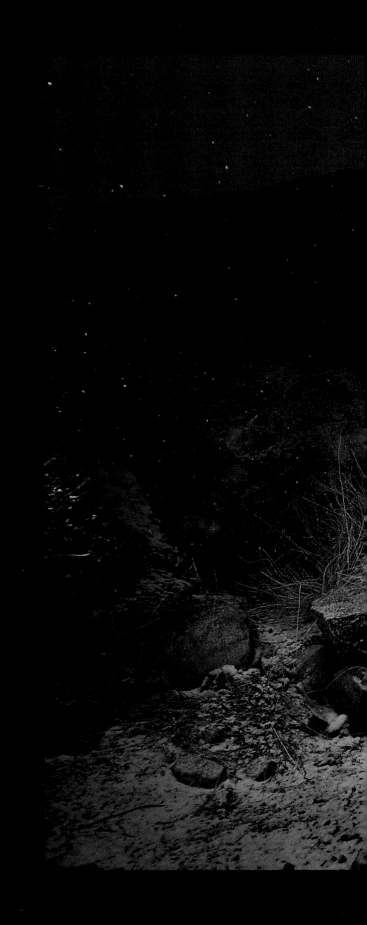

Mark of the snow leopard

RUNNER-UP

Steve Winter

USA

Remotely photographing any animal requires knowledge of the individual's habits, sophisticated technical skills and a huge amount of planning. And photographing it so that the subject appears in the right area of the frame requires great patience. Steve's trip to the Himalayas coincided with the coldest winter in years. Even so, it barely snowed, and he badly wanted to get an image of a leopard in the snow. Having located a trail used by a snow leopard and knowing that the rock in this shot was used for leaving scent marks at night, he set up his remote-controlled camera, composing a scene without the sky in the frame, not wanting a distracting dark block. But after a while, the cat began using the trail in the day as well. And so Steve repositioned the camera to include an element of sky. 'After a month or so,' recalls Steve, 'I finally got the image of the cat marking its territory, complete with a sprinkling of snow – on my birthday.'

Canon EOS Rebel XT + Canon EF-S 10-22mm f3.5-4.5 USM lens at 14mm; 1/200 sec at f16; ISO 100; waterproof camera box + Plexiglass tubes for flashes; Trailmaster 1550-PS remote trigger.

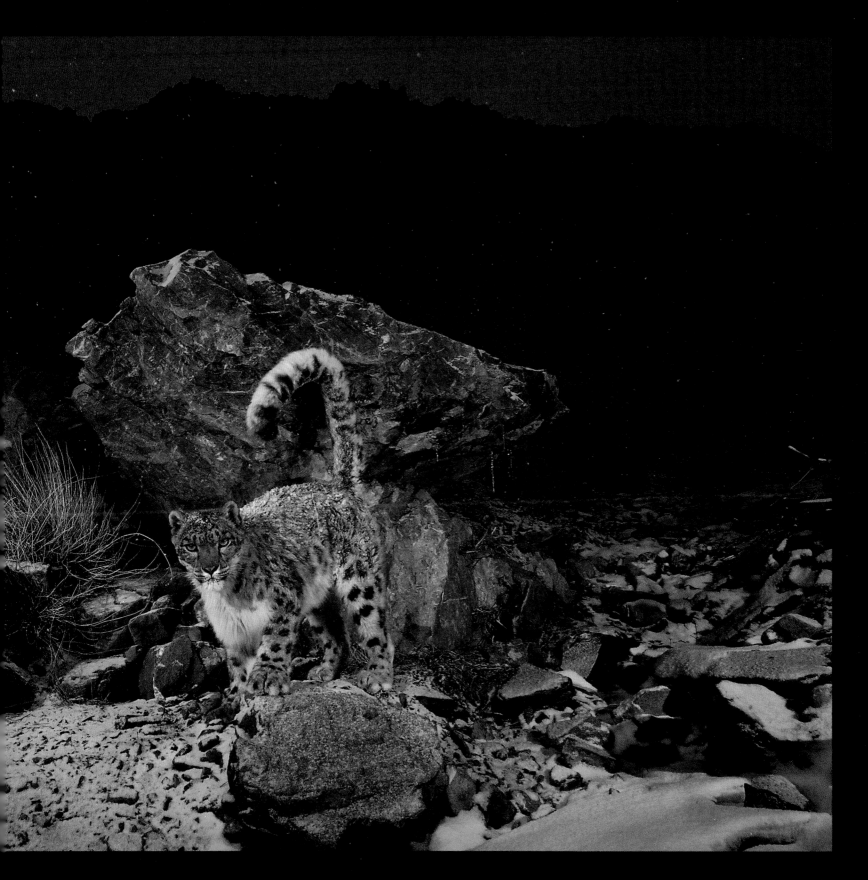

Mouse pounce

HIGHLY COMMENDED

Patrick Centurioni

AUSTRIA

When the farmers mowed the hay, this vixen
helped herself to a feast. Mice, voles and shrews,
no longer hidden by the long grass, were at the
mercy of her sharp-eared precision pounces.
Patrick hid behind his camera bag in a ditch at
the edge of the field, waited and watched.
'She would catch several mice and pile them up
together,' he said. 'When she had about five or six,
she would scoop them up in her jaw and carry
them back to her den.' He spent a week observing
her in the fields near his home on the outskirts of
Vienna. Normally, she would come at dawn and
then again at dusk. One day, he saw two small
cubs trotting by her side. They'd come for a
hunting lesson. 'They watched her quietly from
the side of the field, then rushed out to see what
she had caught. It was one of the most amazing
bits of behaviour I've witnessed.'

**Canon EOS 400D + 300mm f4 lens with 1.4 converter;
1/400 sec at f5.6; ISO 200.**

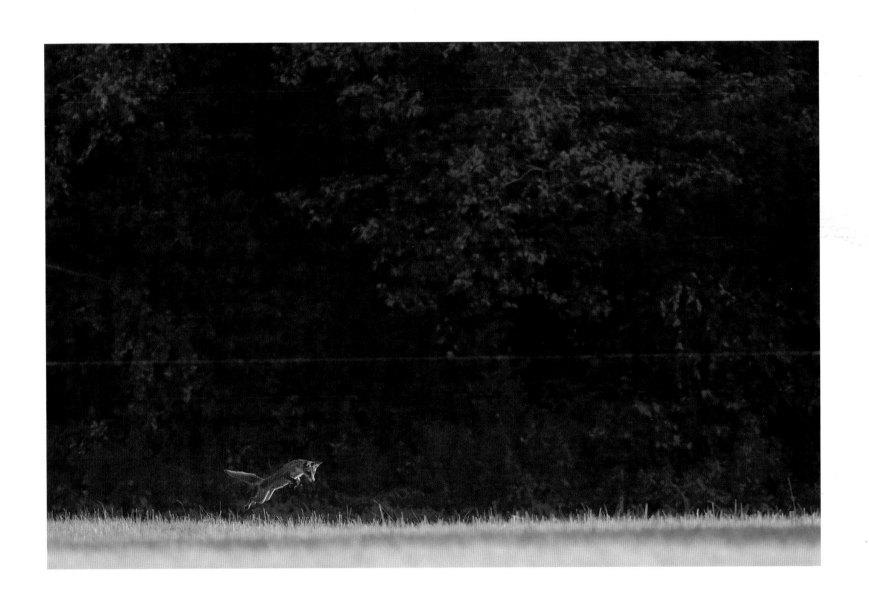

Behaviour
All Other
Animals

The majority of animals on Earth
are not mammals or birds, and
most of them behave in ways that
are little known or understood
and seldom witnessed. So this
category offers plenty of scope.

Deadlock

WINNER

David Maitland

UNITED KINGDOM

The rains finally came. And in Chiquibul Forest
Reserve, Belize, the treefrogs descended from
the canopy, filling the puddles and ponds and
their surrounds. The evening chorus tuned up as
male frogs and toads began serenading females
and fighting off rivals in the race to mate.
It was at about midnight when David discovered
this life-and-death struggle. A cat-eyed tree-snake,
coiled around a branch, was locked in an embrace
with a Morelet's treefrog – a critically endangered
species. 'The snake had failed to get its jaws
around the whole of the frog's head,' says David.
'It wouldn't let go, presumably because the frog
would have leapt away. But it couldn't swallow it,
either.' The kicking frog showed no sign of
weakening. And the stubborn snake wouldn't
budge. 'It was a complete stalemate.' Three hours
later, David realized that the first one to give in

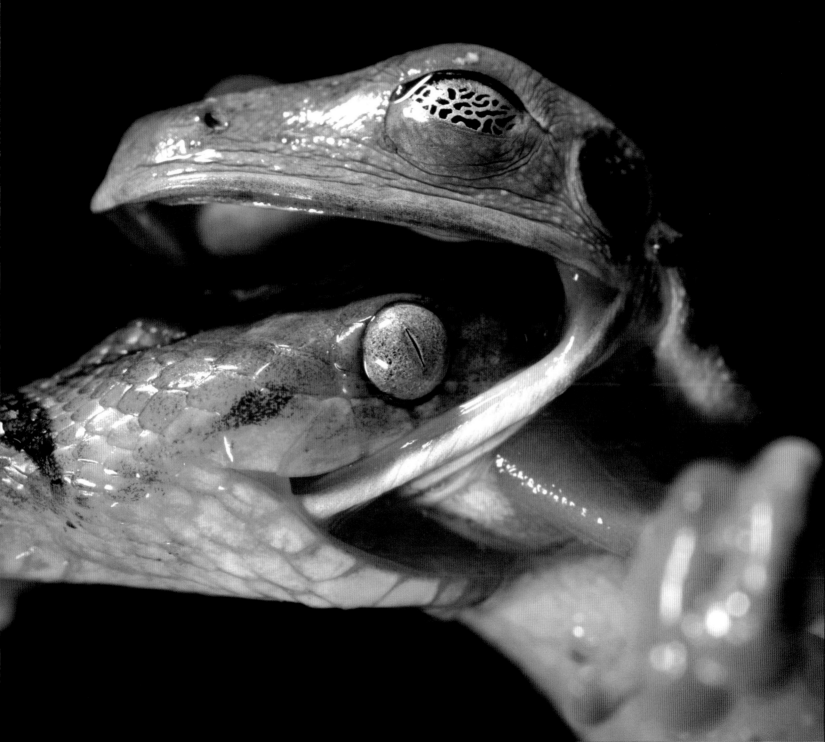

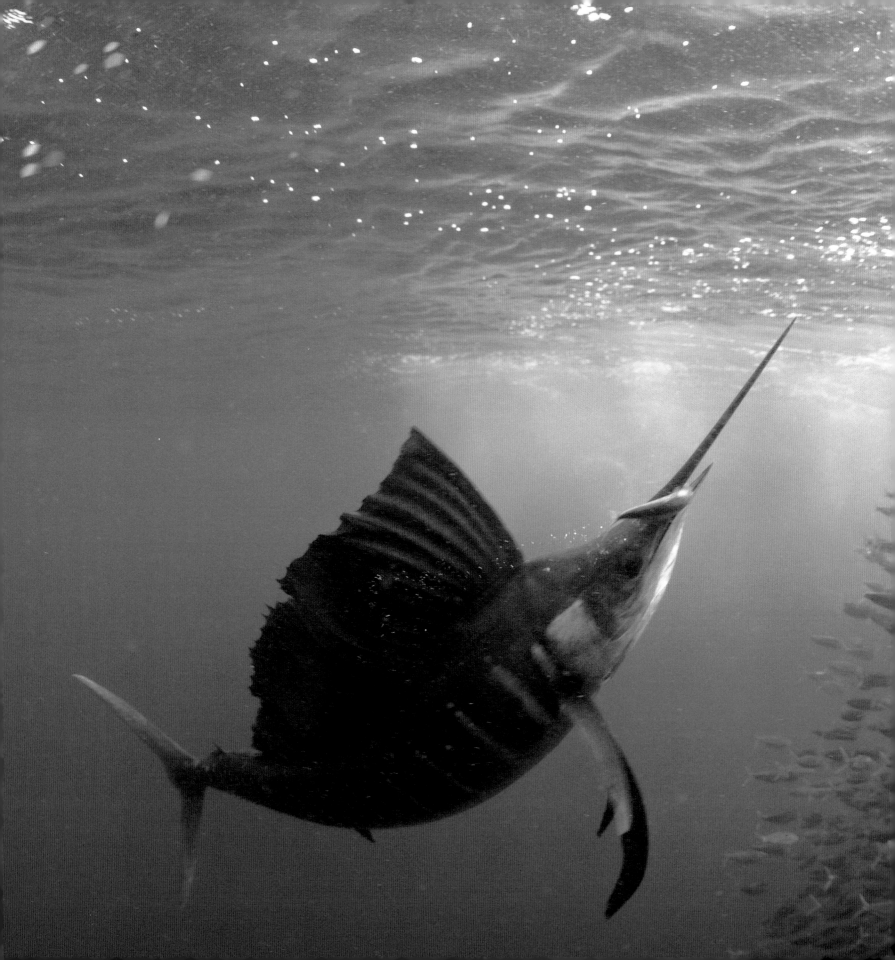

Sailfish strike

RUNNER-UP

Amos Nachoum

ISRAEL/USA

From December to March, along the continental shelf around the island of Isla Mujeres, Mexico, sailfish arrive to feast on great shoals of sardines. Amos persuaded a sport-fishing boat to take him out so he could document the hunt under water. 'It took us days to find a ball of sardines that was still relatively intact,' recalls Amos. 'More than 50 sailfish were 'herding' the sardines in what appeared to be cooperative hunting.' Each took it in turn to rush towards the sardines, raising its impressive 'sail' as it got close to the ball and shaking its bill to knock out sardines. 'Only one in five attempts resulted in success,' says Amos. 'The sardines moved at such speed.' The exact function of the sail of this high-speed hunter is not known, but it could assist in both fast manoeuvring and rounding up prey.

Canon EOS-1Ds Mark III + Canon 16-35mm lens; 1/200 sec at f4; ISO 320; Seacam housing.

Petal procession

SPECIALLY COMMENDED

Adrian Hepworth

UNITED KINGDOM

When Adrian discovered this scattering of pink tonka-bean-tree petals on the forest floor near La Selva Biological Station, Costa Rica, he knew this was exactly the kind of treasure that leafcutter ants would love. So he scoured the surrounding area – and, sure enough, there was a column of industrious worker ants, busily transporting the petals away. 'The contrast of pink and green was irresistible,' says Adrian. He chose a slow shutter to create the pink blur and a flash at the end of the two seconds so that the ants would stand out in front of the blur. The ants were carrying the petals back to their nest, to mash up and use the pulp to cultivate a fungus that they eat. 'It's rare to see them carrying anything other than green leaves,' says Adrian. 'And it's rarer still to see such a large column doing so.'

Canon EOS 5D + Canon 20mm f2.8 lens; 2 sec at f22; ISO 200; curtain flash; tripod

Nature in Black and White

The subject can be any wild landscape or creature, but what a picture must display is skilful and artistic use of the black-and-white medium.

Sun jelly

WINNER

Carlos Virgili

SPAIN

Carlos estimated that the thousands of jellyfish pulsing through the water off Badalona, Spain, stretched for more than a kilometre. Diving through the jelly mass, protected from their stings by his wetsuit and mask, he realized the only way to photograph them was from the sandy bottom, so that they would be backlit by the sun. He focused on this 30cm individual shiff-arms jellyfish, shooting in black and white to emphasize the sensual form and the contrasting textures. Jellyfish 'blooms' such as this one seem to be on the increase in the Mediterranean. A number of factors are involved, from ocean currents and nutrients to the temperature and oxygen levels of the water – and the absence of predators, including turtles, large numbers of which are caught in fishing tackle.

Nikon D2x + 12-24mm f4 Nikkor lens; 1/500 sec at f16 (-0.7 compensation); ISO 100; Subal housing.

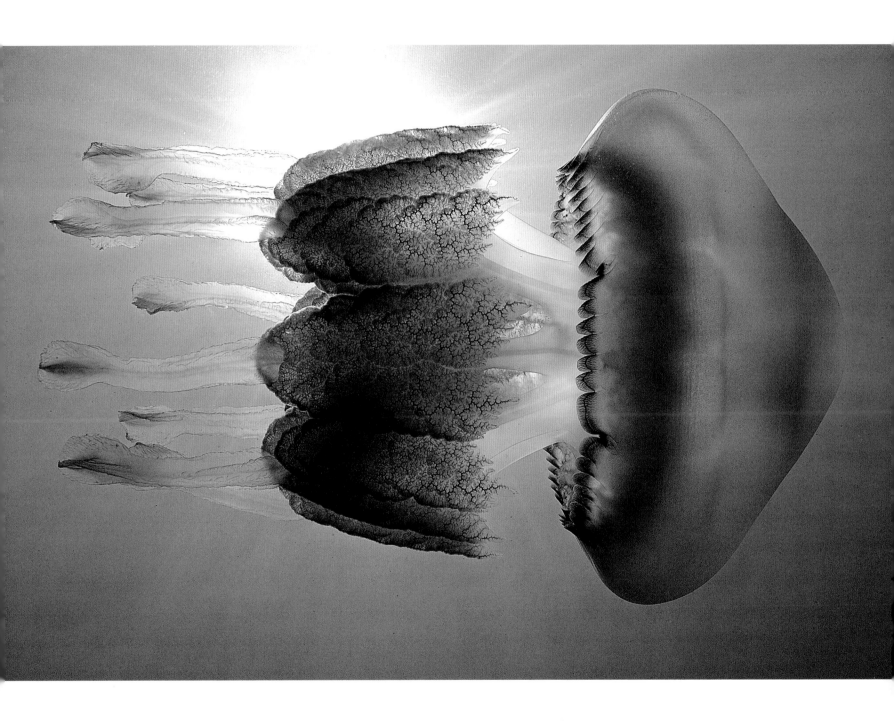

Storm terns

RUNNER-UP

Guillaume Bily

FRANCE

The power of the storm was impressive, and as it churned up the sea off Iceland, the waves smashed onto the beach, chipping shards of ice from the frozen edge. Dipping over the waves was a huge flock of Arctic terns, diving for small fish in the breakers with ease. 'I was struck by how delicate they looked against the powerful seascape,' says Guillaume, 'and the way they swooped in synchrony with the storm-fuelled waves.'

**Nikon D2x + Nikon 300mm f4 lens; 1/15 sec at f32;
ISO 100; tripod.**

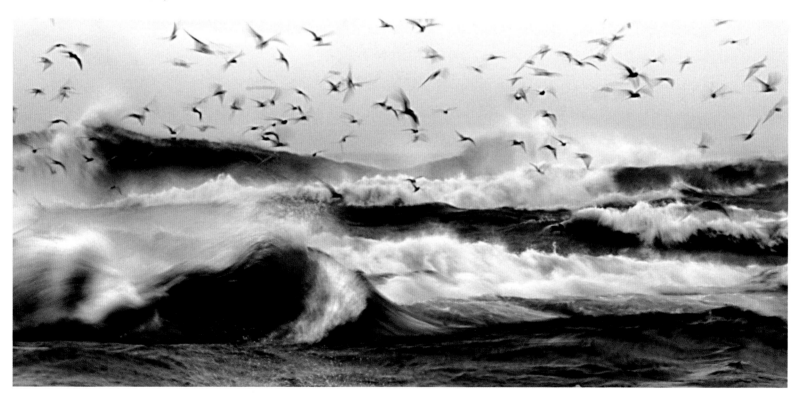

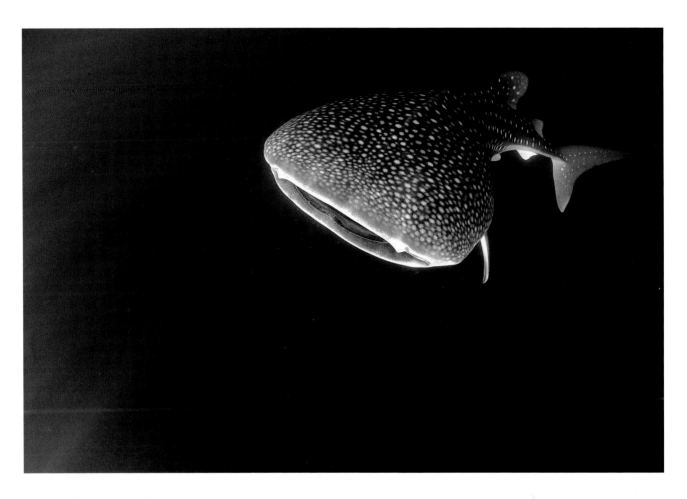

Little big mouth

HIGHLY COMMENDED

Fergus Kennedy

UNITED KINGDOM

Fergus hit the whale-shark jackpot in the Gulf of Tadjourah, Djibouti, when he found himself snorkelling among a filter-feeding frenzy of these giant fish. Below him, emerging from the depths, rose a small one, just three metres long. 'The bold shapes and textures were perfect for a black-and-white rendition,' says Fergus, who waited to take the shot until the whale shark reached a point where its head was lit by the late-afternoon sunbeams.

Canon EOS 5D + Sigma 15mm f2.8 fisheye lens; 1/80 sec at f6.3; ISO 200; Ikelite housing.

Animals in Their Environment

A winning photograph must convey a sense of the relationship between the animal and where it lives, with the environment being as important a part of the picture as the subject is.

Snow swans

WINNER

Yongkang Zhu

CHINA

Rongcheng Swan Lake Nature Reserve in eastern China is a major overwintering sanctuary for whooper swans from farther north. But even here, winters can be harsh, and when the fresh water and wetlands freeze over, the birds are forced to feed in the fields, digging through the snow for grass. To photograph the swans in their environment meant enduring the same conditions – snowstorms and high winds that roll the snow across the flat land in great waves. Crouched on a rise overlooking the Swan Lake, Yongkang captured the scene as one swan took off into the squall, followed moments later by the others. 'The storm was so bitter,' says Yongkang, 'I wished I could have escaped along with the swans.'

Canon EOS 20D + Sigma 300-800mm f5.6 lens at 300mm; 1/1250 sec at f6.3; ISO 200; tripod.

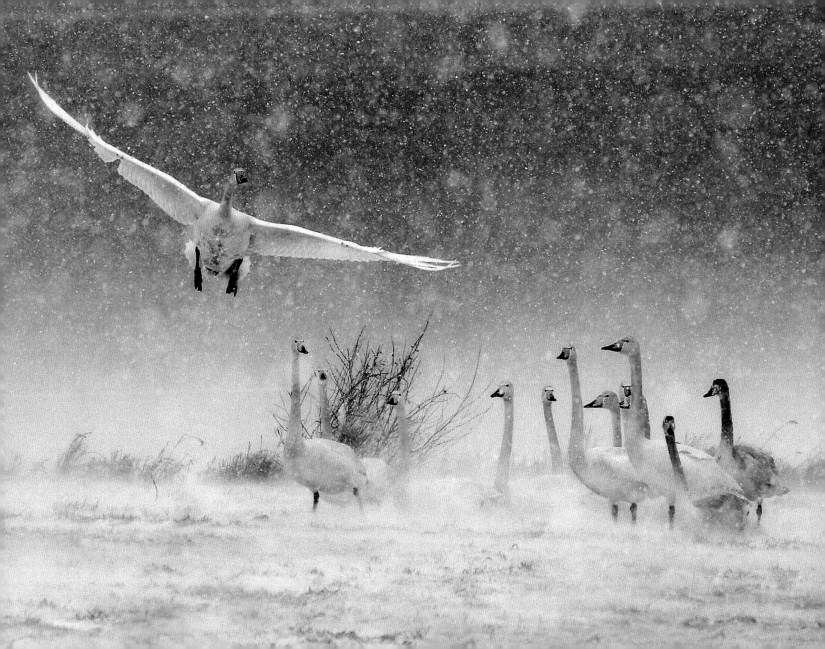

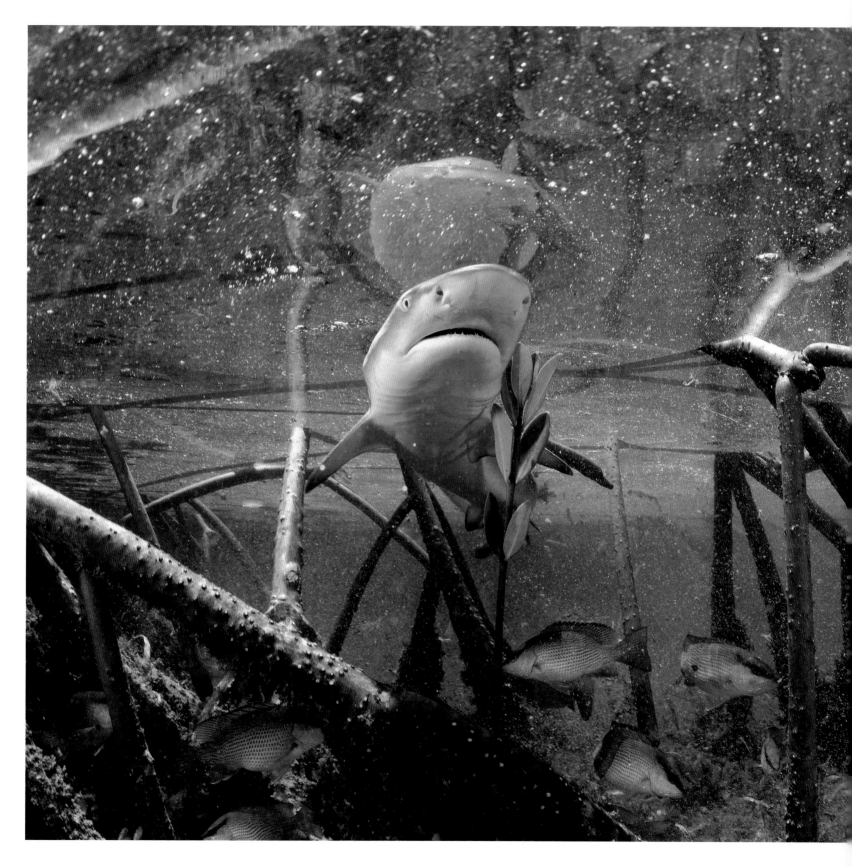

Shark nursery

RUNNER-UP

Brian Skerry

USA

A newborn lemon shark pup enjoys the safety and
sustenance of its mangrove nursery lagoon on
the coast of Bimini island in the Bahamas. Though
it looks huge, the pup is only about 60cm long.
It was born live, along with 30 or so littermates,
and will spend a couple of years in the nursery
before moving into the open sea. Mangroves are
critical nurseries for many fish – especially lemon
sharks – and protect the coast from storm surges.
But the development of new holiday resorts means
that the mangroves are starting to be cleared.

**Nikon D2X + Nikon 16mm lens; 1/160 sec at f8; ISO 200;
Subal housing; two Sea & Sea YS350 strobes on 1/4 power.**

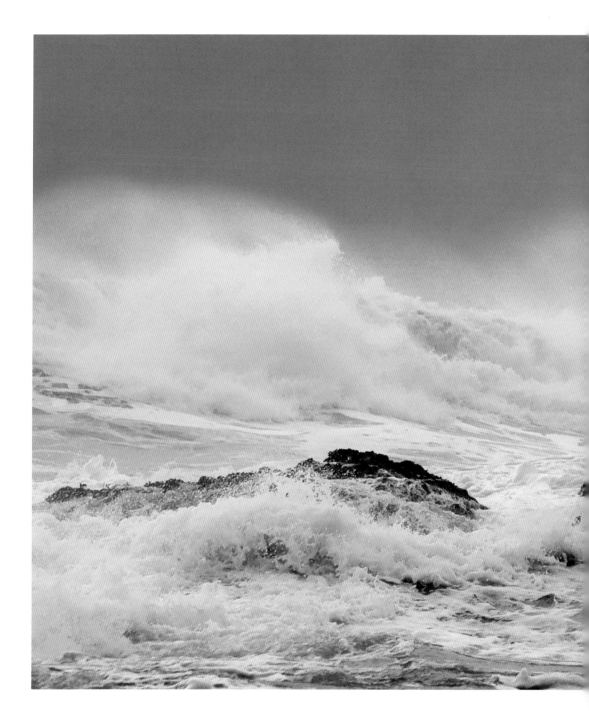

Surf gull

SPECIALLY COMMENDED

Michael Lambie

CANADA

A winter storm had brought Michael out to the Vancouver Island coast. Being the evening of the full moon and just past the equinox, the storm waves were particularly big. But the focus of Michael's photography became a lone glaucous-winged gull, which seemed set on challenging the breaking waves. It would land on bare rocks and then be forced to take off again after a few seconds by the next crashing wave. 'Keeping my equipment dry was a constant challenge,' says Michael. 'I was battered by wind, rain, snow, sleet and hail as I stood on rocks just above the high-tide line. But that was nothing to what that gull was going through.'

Canon EOS-1D Mark III + Canon 70-200mm f2.8 IS USM lens at 200mm; 1/1250 sec at f7.1; ISO 1600; Gitzo 1223 tripod + Really Right Stuff BH-55 ballhead.

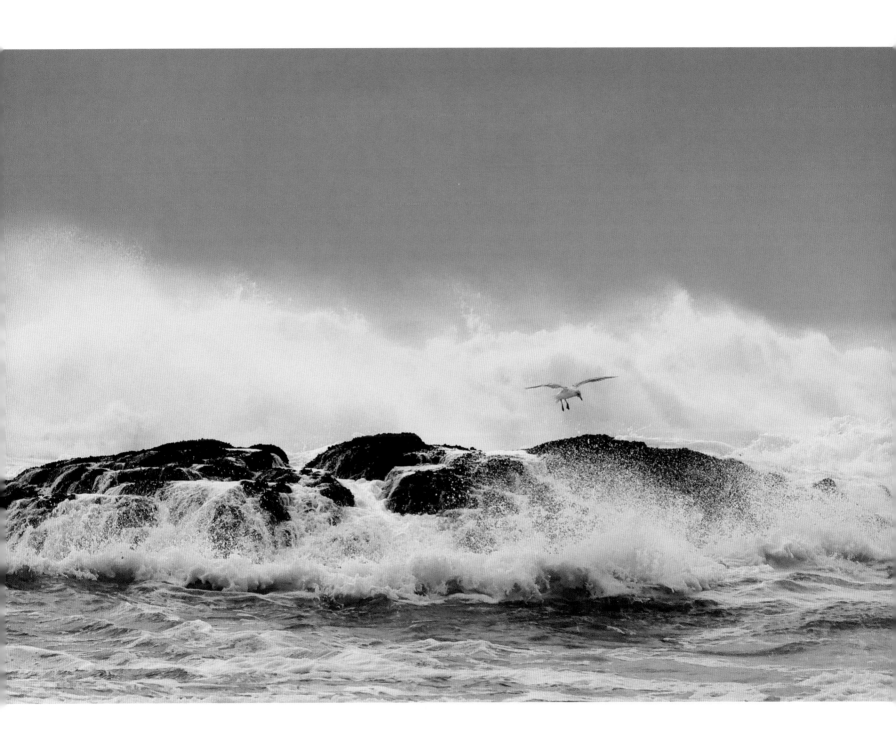

Bewick lift-off

HIGHLY COMMENDED

Ellen Anon

USA

Ellen's fingers, double-gloved, had gone numb.
Necklaces of ice-beads clung to the Bewick's
swans' necks. Waves breaking against the shore of
Japan's Lake Kussharo, Hokkaido, were freezing
solid. Ellen had been photographing the swans
since before dawn. At first, they had scoured the
picnic area on the shore for food. But when they'd
eaten the last frozen crumbs, they headed back
onto the lake. 'I was in awe that these gorgeous
birds could face the water under such cold
conditions,' says Ellen. By now, the wind had
churned the lake up into white peaks that echoed
the snowy mountains behind. When one swan
began to taxi along the churning runway, Ellen
managed to instruct her frozen index finger to
release the shutter just before take-off.

Canon EOS-1D Mark II + Canon 28-300mm f3.5-5.6 lens;
1/800 sec at f11; ISO 400.

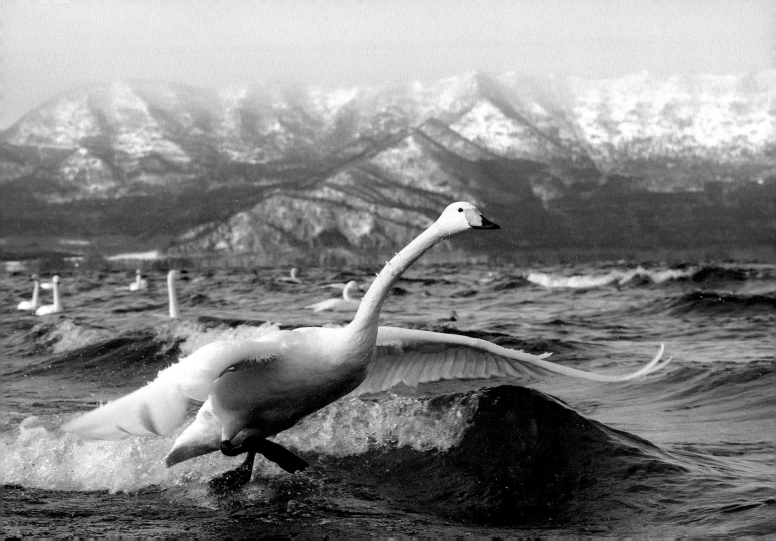

Wolf-watch

HIGHLY COMMENDED

Florian Schulz

GERMANY

Florian glimpsed this family of grey wolves far in the distance, moving across the foothills. He had been waiting five weeks for a chance to photograph the nervous pack, and so he lay as low and still as possible as they drew closer. The adults were probably taking their grown-up pups around the territory, and every so often there would be a flurry of activity as one of the youngsters sprang after a hare or a ptarmigan. 'As they came closer, I could see by their pricked ears that they were intently interested in something,' says Florian. It was then that he caught sight of a lone wolf watching them with equal interest. To place the family in their tundra environment and capture the atmosphere of the scene, he risked using a 70-200mm lens rather than a telephoto, knowing that he would have just a few seconds to compose the shot before the wolves melted away into the landscape.

The wolf paradise of Alaska's Denali National Park ends abruptly at the park borders. 'How long will it take', says Florian, 'before the importance of creating large enough buffer zones around parks is understood? In winter, these same wolves are forced to cross the park boundaries in search of food. They need the freedom to roam without falling foul of snares or bullets.'

Nikon D2x + 70-200mm f2.8 Nikkor lens; 1/125 sec at f2.8; ISO 400.

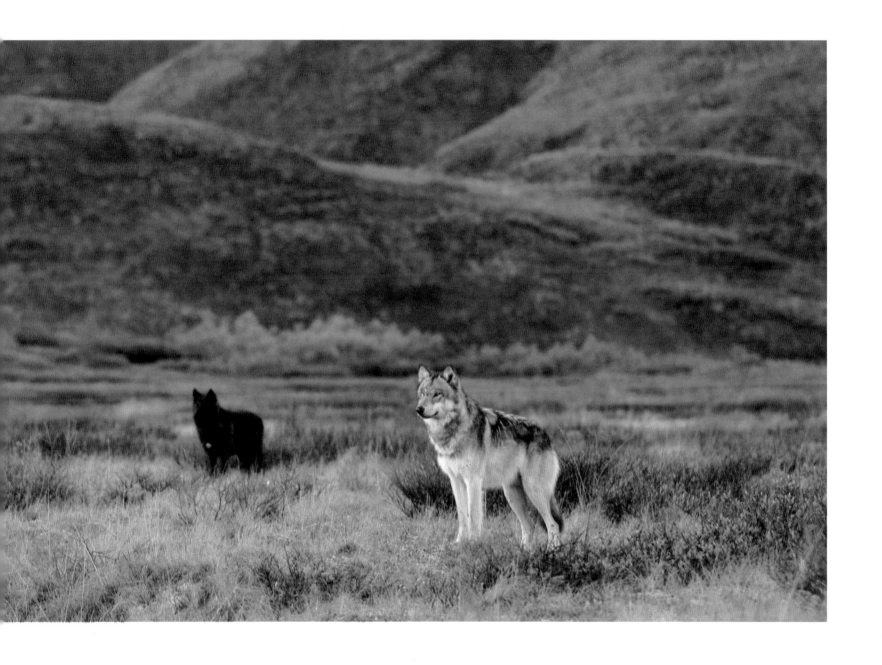

Sand sprinters

HIGHLY COMMENDED

Dan Mead

USA

Far away and sprinting – that was the kind of ostrich sighting Dan was used to in Namibia. Then, late one morning, on a dried-up riverbed on the Skeleton Coast, he came across a lone ostrich chick. It was struggling to keep up with the rest of its family some distance ahead. The mother was in the lead, scouting, and seemed to have judged the situation – a straggling chick, a strange vehicle, a vulnerable family – because her next move took Dan by surprise. 'She suddenly turned sharp right and headed straight up the nearest dune,' he says. 'It must have been 100 metres high and at an angle of 30 degrees. The sand slipped away under her feet. It was an amazing effort.' The father chaperoned the family up the slope, while the mother waited for them at the top. The little straggler finally caught up with its siblings, and the whole family disappeared over the crest of the dune. Midday light is not usually a photographer's choice, but in this case, the overhead sun was ideal – creating the flat canvas and harsh shadows that contribute to a perfect composition.

Canon EOS 5D + Canon 100-400mm f4.5-5.6 IS USM lens at 400mm; 1/640 sec at f9; ISO 100.

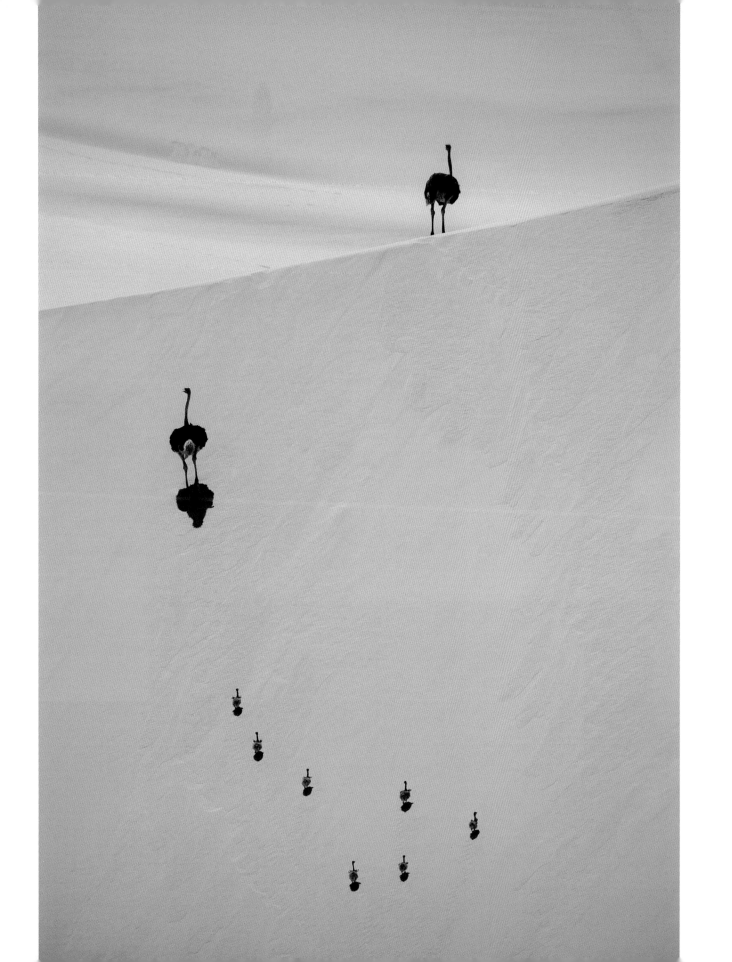

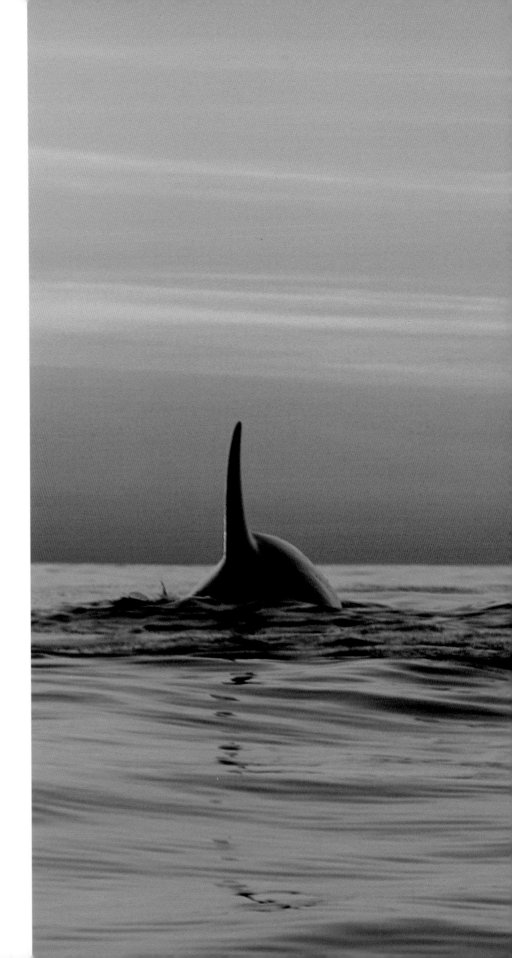

Orcas at sunset

HIGHLY COMMENDED

Nuno Sá

PORTUGAL

Pulling on his mask and snorkel, Nuno felt slightly nervous. He'd often swum with whales and dolphins, but never with orcas. The pod had been sighted just that day cruising off São Miguel Island, in the Azores. 'As soon as I dropped into the water,' Nuno remembers, 'one of the males spun round and came straight at me, its six-metre body stiff, as though it were about to attack. It circled me, just a metre away. We looked each other in the eye.' Nuno knew he had to be careful, but he didn't feel any aggression from the whale, just curiosity – he was merely being checked out. He spent five hours in and out of the water with the eight orcas – females and calves and two males – taking this final shot as the light turned gold. The next day, the pod killed a fin whale.

Canon EOS 20D + Canon 70-200mm f4 IS USM lens at 70mm; 1/80 sec at f13; ISO 200.

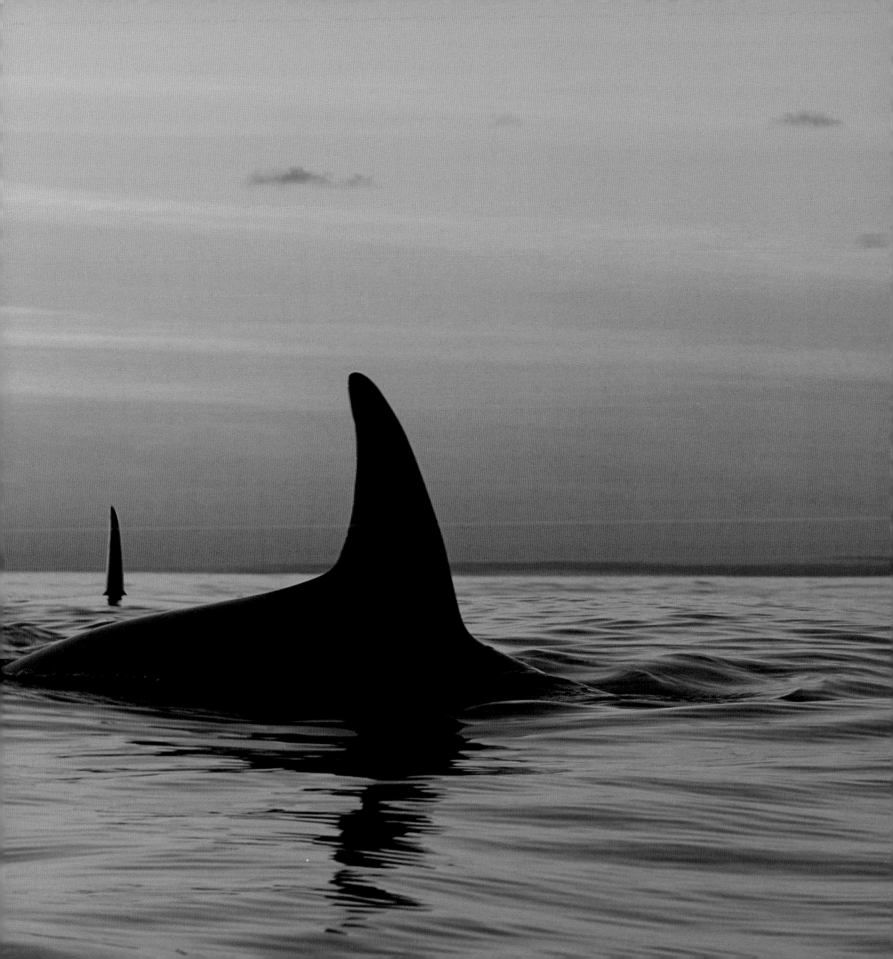

Bat house

HIGHLY COMMENDED

Christian Ziegler

GERMANY

A common big-eared bat circles its fallen-tree-trunk roost. Though all three bats in the family group using the roost are usually awake in the late afternoon, they won't exit in search of insects until dusk but will kill time flying around the roost in bursts of activity. The species was one of the subjects Christian focused on in his quest to illustrate how different feeding and roosting habits allow 74 species of bat to live together on the tropical island of Barro Colorado in Panama. To do this meant working closely with scientists from the Smithsonian Tropical Research Institute. Lighting the picture was tricky, as Christian wanted to show the total environment – the rainforest outside the trunk as well as the inside of the bat's home and the bat itself. This required a complex combination of camera settings and remote lights and took many months of hot, sweaty and mosquito-ridden days and nights.

Canon EOS 5D + 16-35mm lens; 4 sec at f8; two strobes for fill flash + video background lighting.

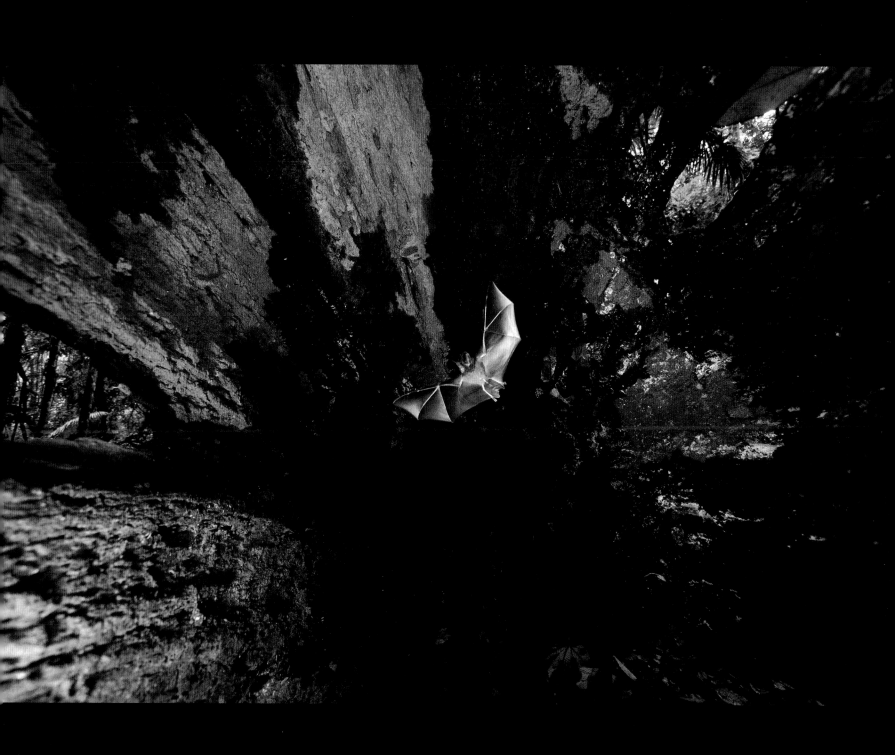

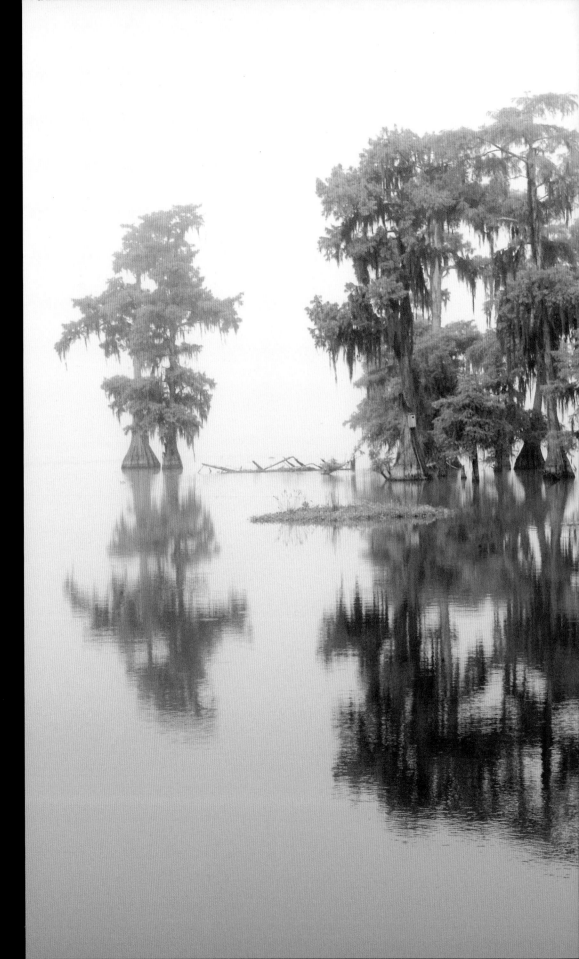

In Praise
of Plants

The aim of this category is to showcase
the beauty and importance of flowering
and non-flowering plants, and fungi,
whether by featuring them in close-up
or as part of their environment.

Swamp cypress

WINNER

Cece Fabbro

USA

The scene seems so serene, so quiet. Yet it was
anything but. The stand of swamp cypress is in
Lake Martin in Louisiana, USA, which is also home
to a rookery of more than 20,000 breeding
herons, egrets, white ibises, roseate spoonbills,
owls and ospreys. 'From dawn to dusk they
squawk, squeak and bark over mates, nesting sites
and nest-building materials,' says Cece, who had
gone to the lake intending to photograph roseate
spoonbills. But what fascinated her was this
isolated stand of ancient swamp cypress, perhaps
half a century old and dripping with Spanish moss.
In the early morning mist, 'there was something
mystical, almost eerie about them,' she says.

Canon EOS-1D Mark II + 28-135mm f3.5-5.6 lens at 50mm;
1/100 sec at f22; ISO 400; Gitzo tripod + Kirk ballhead.

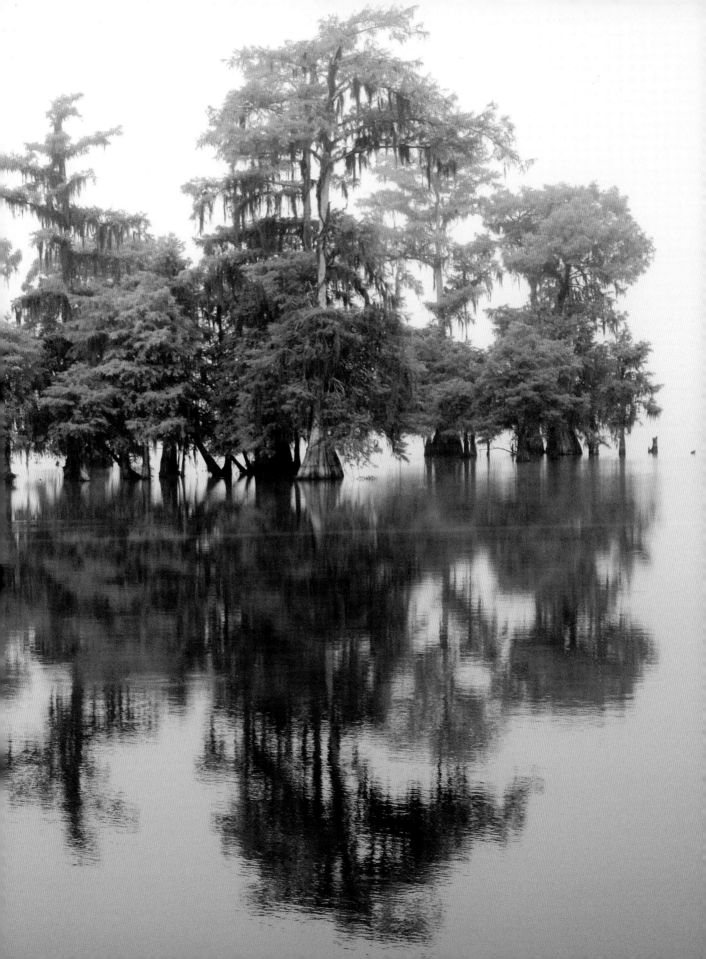

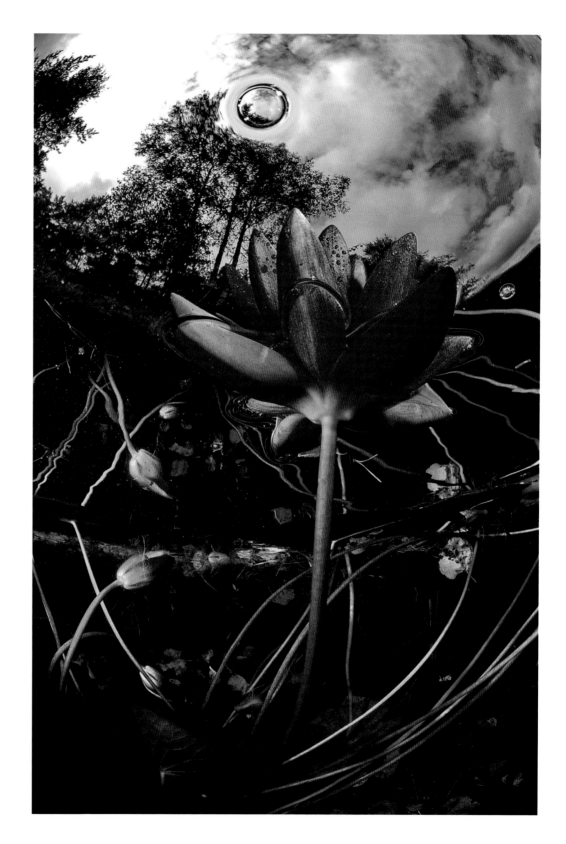

Celebration lily

RUNNER-UP

Fredrik Ehrenström

SWEDEN

In 2004, when Fredrik saw a perch in a small lake near Gothenburg, his heart soared. It was a sign that the lake was recovering from acid-rain pollution. By the late 1990s, nearly a quarter of Sweden's lakes had become polluted by airborne pollutants from Europe such as sulphur dioxide and nitrogen oxide, and over 60 years, the pH had fallen from a healthy 6.2 to 4.5. Fish could no longer breed. Crayfish, lice, snails, mussels and plankton disappeared, and the lakes were eerily clear. Fredrik found himself photographing in visibility of up to 60 metres. 'Water lilies were one of the few species that could tolerate such toxic conditions,' he says. In the past decade, Europe has cut its emissions. Today the pH is near a healthy 5, and the lake is once again murky with plankton. 'Now I have to get much closer to the water lilies,' Fredrik says.

Nikon D200 + AF Fisheye 10.5mm f2.8 DX Nikkor lens; 1/60 sec at f16; ISO 100; Hugyfot housing; two Sea & Sea YS300 strobes.

Boletus in the rain

SPECIALLY COMMENDED

Thierry Van Baelinghem

FRANCE

After a week of heavy storms, Thierry decided to make photographic use of the torrential rain. He knew that the wet conditions would mean that the Monts du Lyonnais woods near his home outside Lyon would now be full of mushrooms and toadstools. Taking a waterproof canvas for shelter, he set out, head down, scanning the forest floor for the perfect fruiting body. The quirky angle of this bay bolete – in full bloom, cap rounded and rich brown, at the peak of its maturity – caught his eye, and he set up his gear. 'The challenge was to keep my equipment dry,' he remembers. Lying on the soggy leaf-litter, he waited all afternoon until the sun was soft enough to bring out the delicate colour of the bolete and surrounding moss, and then he turned his attention to the best way to use the rain to enhance the toadstool's organic form.

Nikon D100 + 60mm f2.8G ED AF-S micro Nikkor lens; 1/60 sec at f5.6; ISO 200.

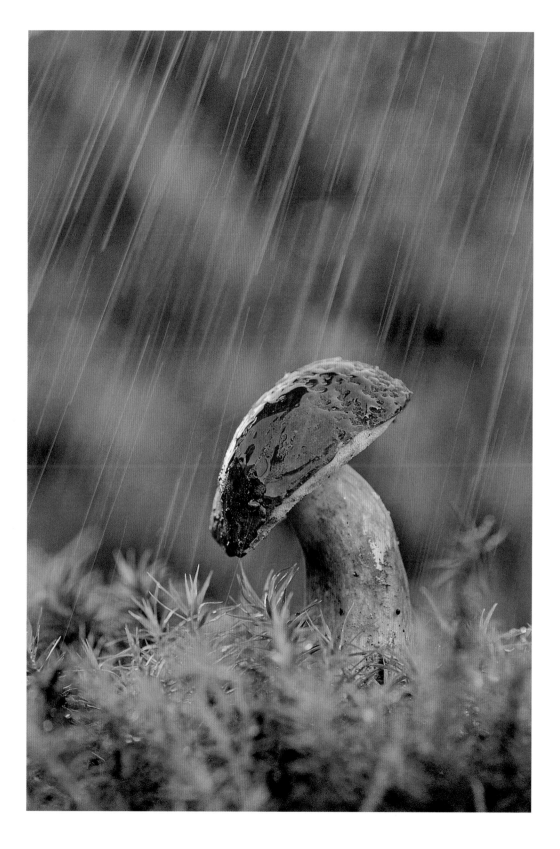

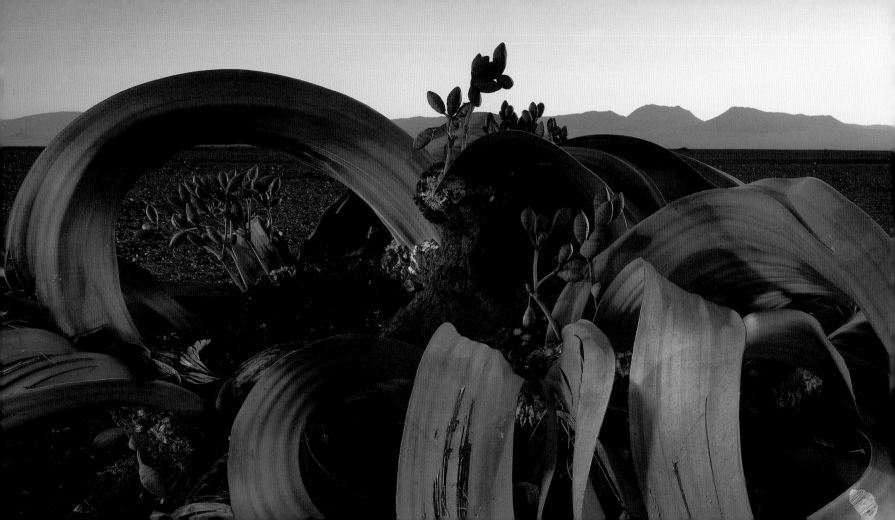

Ancient survivor

HIGHLY COMMENDED

Koos van der Lende

SOUTH AFRICA

Two leaves, a stem base and roots. That's all there is to a welwitschia. Yet this simple arrangement means that the plant can cope with the most desiccated of environments, where no more than 15mm of rain falls each year. It takes root where no other plant would dare try. Its long, curled ribbon leaves, split with age and singed by the hot ground, funnel the morning dew down to the roots. Some individuals could be more than 1500 years old. These 'living fossils' are so unlike anything else that they warrant a genus all their own – and a classic portrait. Koos photographed his subject, which is at least 200 years old, in the desert of Namibia's Messum Crater, close to the Skeleton Coast. 'I loved the circle the leaf made on the left,' he says, 'and used 12 reflector boards to bounce the sunlight back to get the detail.'

Fuji GX617 panoramic + 90mm lens; 8 sec at f45; Fuji Velvia 50 120mm film; grey filter to compensate for the one-stop light fall-off to the sides; polarizing filter + four-stop neutral-grey gradual filter; Gitzo heavy-duty tripod; 12 reflector boards.

Bottle in the wind

HIGHLY COMMENDED

Koos van der Lende

SOUTH AFRICA

At first, the vast plain looked empty. Flat, dry and windswept, it stretched some 75 kilometres between the Kuiseb canyon and the Walvis Bay road in Namibia's Namib-Naukluft National Park. Then Koos noticed a lone tree, stubby and stubborn in the gravel. 'I set up four big reflector boards with stands and used a compass to plot exactly where the sun would set,' he says. 'The wind was blowing exceptionally hard, but it didn't bother the tree, which has grown leaning with the wind.' Bottle trees survive in such hostile places by storing water and nutrients in their trunks. 'I was just so amazed that this empty, barren world could be home to this fat, happy little tree.'

Fuji GX617 panoramic + 90mm lens; 15 seconds at f45; Fuji Velvia 50 120mm film; central grey filter to avoid one-stop fall-off to the sides; polarizing filter; Gitzo heavy-duty tripod; four reflector boards.

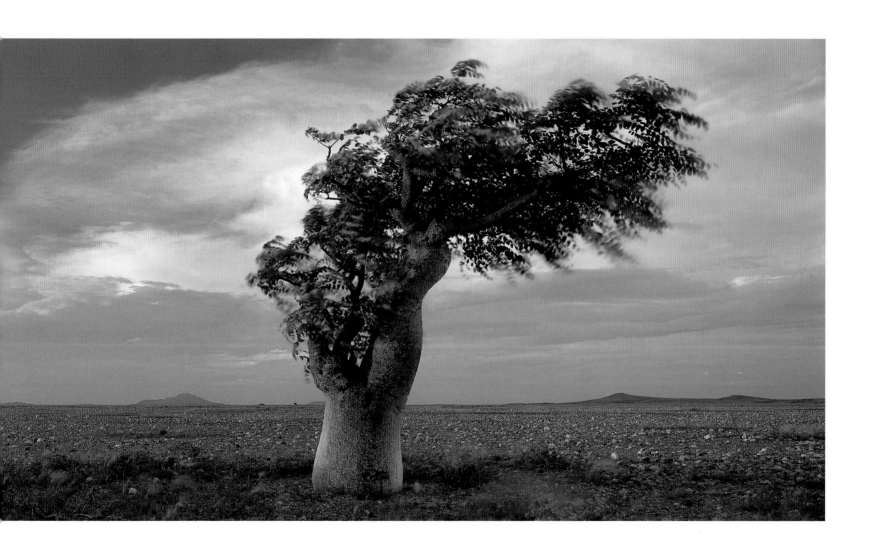

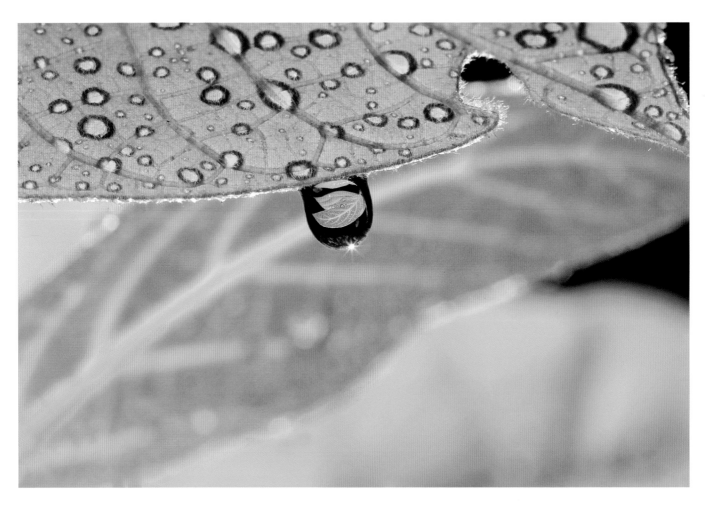

Leaf drop

HIGHLY COMMENDED

Darran Leal

AUSTRALIA

In 2006, the rainforest in far north Queensland had been rich with photographic opportunity. Then Cyclone Larry reduced the area to stumps and tangled undergrowth. Picking his way through the ruins a year later, Darran came across a small tree backlit by the sun and sparkling with rain. A jewel-like drop, with its perfect reflection of leaves inside, 'struck me as a great symbol of the regrowth of the rainforest,' says Darran, 'but I had to move fast'. The challenge was to capture the moment in spite of gusts of wind and the great magnification required.

Canon EOS 5D + 100mm macro lens; 1/125 sec at f22; ISO 100; Canon 580EX flash + TTL auto cord.

Saffrondrop bonnets

HIGHLY COMMENDED

Danny Laps

BELGIUM

As a macro-photographer always on the lookout for exquisite life to aggrandize, Danny was pleased to find these diminutive mushrooms – saffrondrop bonnets in a dark Belgian wood. He was charmed by their delicate, glowing colours, softened by the light streaming through the beech leaves. 'Through my lens,' says Danny, 'it felt as though I were looking at a scene fresh from a child's tale. Only the fairy was missing.'

Nikon D200 + 200mm f4 micro lens; 1/6 sec at f6.3; ISO 100; Manfrotto 055 tripod + Arca-Swiss Z1 ballhead.

fresh water, shot under the water.
The pictures must also be memorable,
either because of the behaviour
displayed or because of their aesthetic
appeal – and ideally, both.

First encounter

WINNER

Brian Skerry

USA

'Swimming along the ocean bottom with a
14-metre long, 70-tonne whale', says Brian,
'was the single most incredible animal encounter
I have ever had.' It was probably memorable for
the southern right whale, too, which became
fascinated by Brian's dive buddy. The picture was
taken some 22 metres down off the Auckland
Islands, far south of New Zealand, and emphasizes
the sheer bulk and scale of the animal – seldom
obvious from the ocean surface. Brian had travelled
to these remote and stormy islands specifically to
photograph the population of right whales that
feed in the cold water around them. Almost
certainly the right whales had never encountered
humans under water, and were as curious about
the divers as the divers were about them.

**Nikon D2x + 10.5mm f2.8 lens; 1/80 sec at f6.3;
Subal housing.**

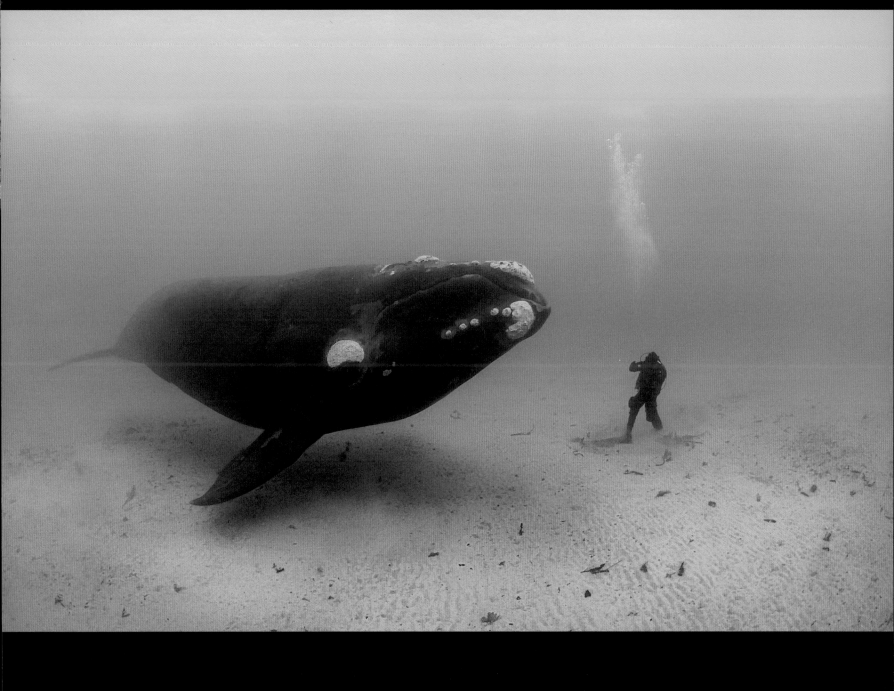

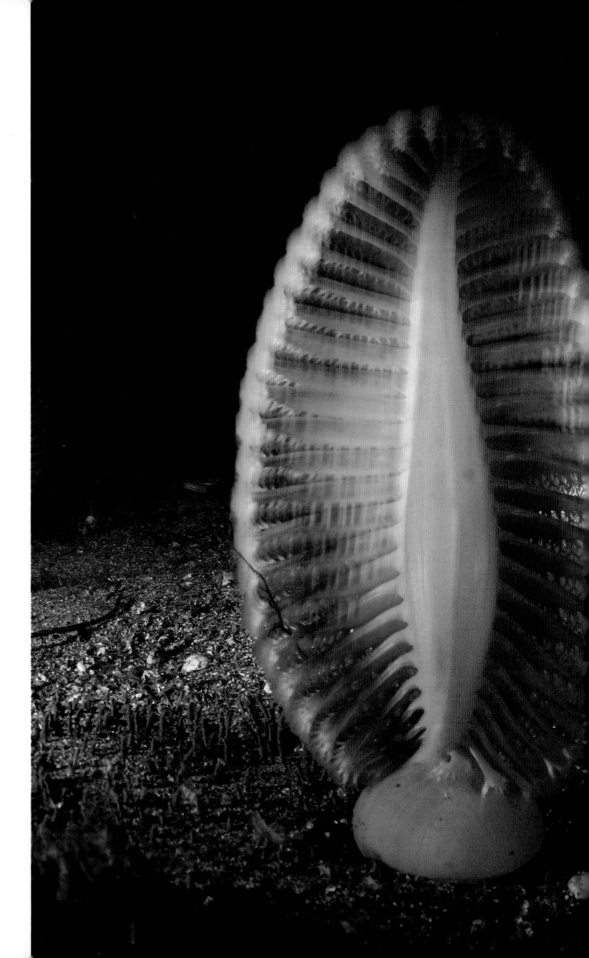

Underworld

RUNNER-UP

Brian Skerry

USA

A blue cod takes a stroll on its fins through an otherworldly garden of vibrant soft corals and starfish. The soft corals are sea pens – usually found at considerable depths. But here they are growing in the shallow waters of Long Sound Marine Reserve in New Zealand's Fiordland, where tannin-stained surface water blocks out sunlight, 'tricking' deep-water animals such as sea pens into settling at shallower depths. Careful use of flash has brought them to light, their 'arms' outspread to filter micro-organisms from the swirling water. Fragile marine areas such as this one still exist in New Zealand waters thanks to federal protection.

Nikon D2x + 16mm lens; 1/30 sec at f9; ISO 200; Subal housing; two Hartenberger strobes on 1/4 power, additional strobe used to light more distant subjects.

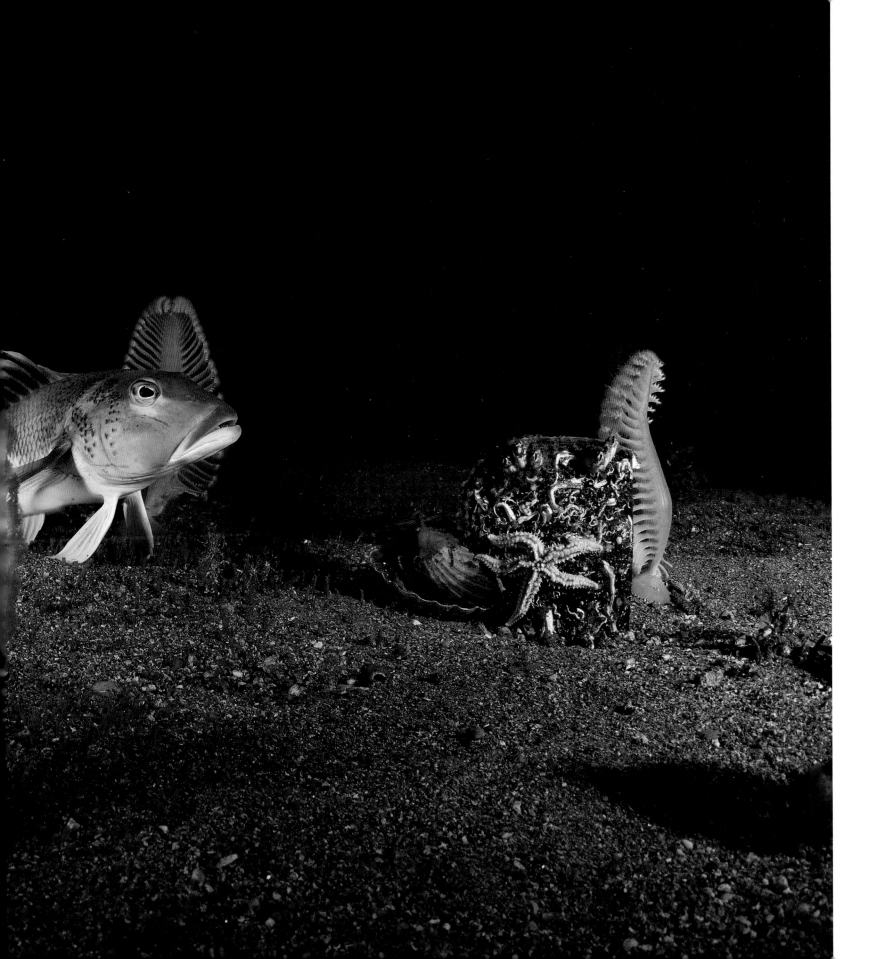

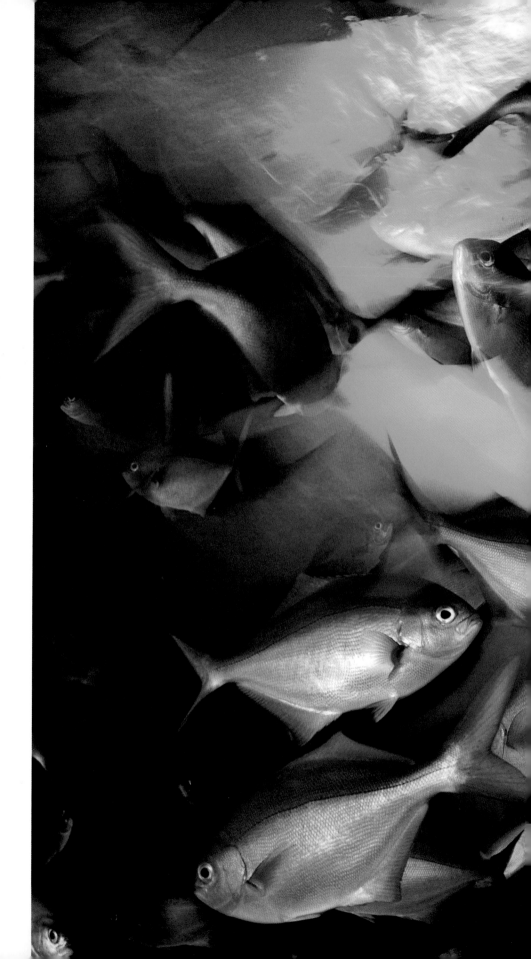

Sea of life

SPECIALLY COMMENDED

Brian Skerry

USA

A red pigfish moves through a school of
blue maomao in a swirl of energy and colour.
'This is how I imagine the oceans may have looked
hundreds of years ago – before overfishing
depleted stocks,' says Brian. The picture was taken
at the Poor Knights Island Marine Reserve, east of
New Zealand's North Island, where he had gone
specifically to take pictures to celebrate the
abundance of healthy marine ecosystems.
The creation of reserves here has revealed how
resilient the ocean can be if given time.

**Nikon D2x + 16mm lens; 1/8 sec at f13; ISO 200; Subal
housing; two Hartenberger strobes on 1/4 power.**

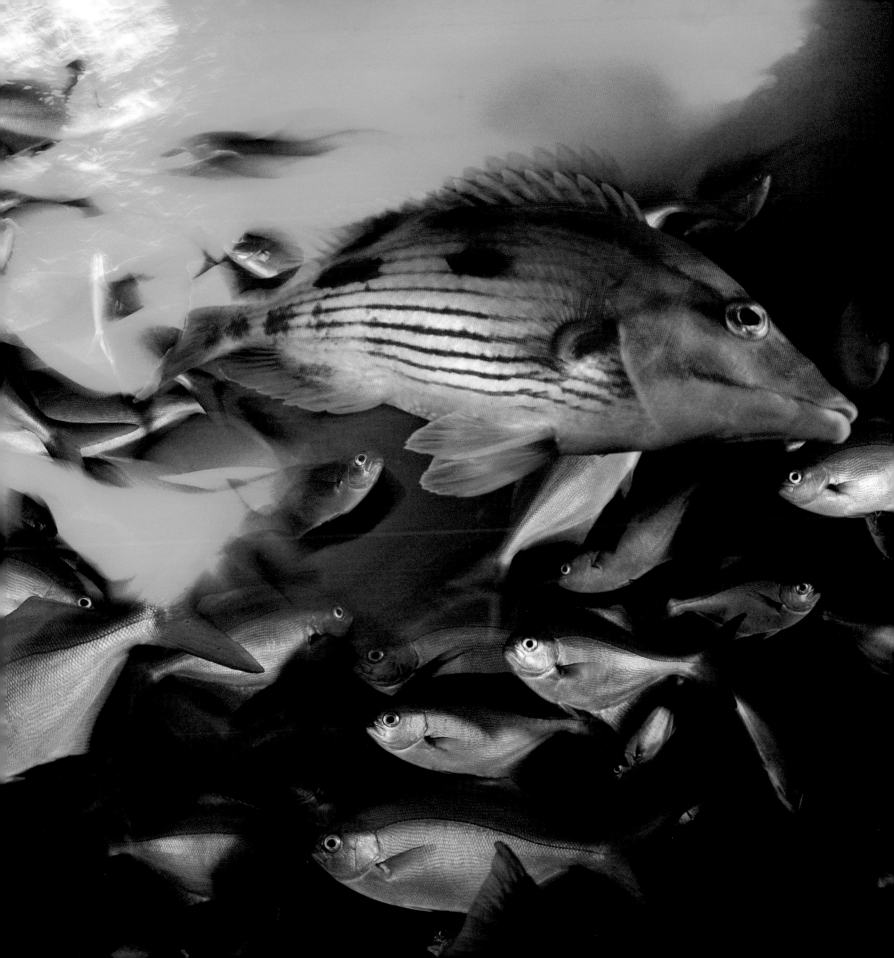

Daddy long legs

SPECIALLY COMMENDED

Jordi Chias

SPAIN

Jordi came across this strange arrangement of
spikes and spines while diving near Puerto de
Mogán off the southern coast of Grand Canary in
the Canary Islands. As he moved in closer, he
realized they were a male and female arrow crab
backed against long-spined sea urchins. The female
had eggs in her swollen abdomen, and her mate
was standing over her, clasping her with his
clamps to stop other males from mating with her.
Arrow crabs are often found with sea urchins,
presumably using them as protection from
predators – their impossibly long legs useful for
avoiding actual contact with the urchins.
'The spikes and tangle of long legs made a
wonderfully graphic image,' says Jordi, 'and the
cobalt-blue background with a school of small
silver fish flitting past was like a sky of stars.'

**Canon EOS 5D + 17-40mm f4 lens at 40mm; 1/40 sec at
f11; ISO 100; Sea & Sea housing; two Sea & Sea
YS110 strobes.**

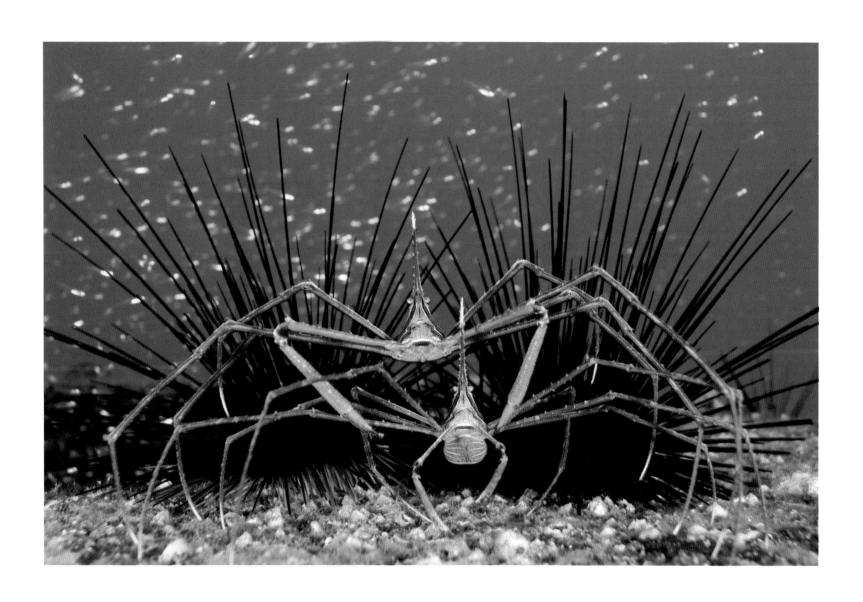

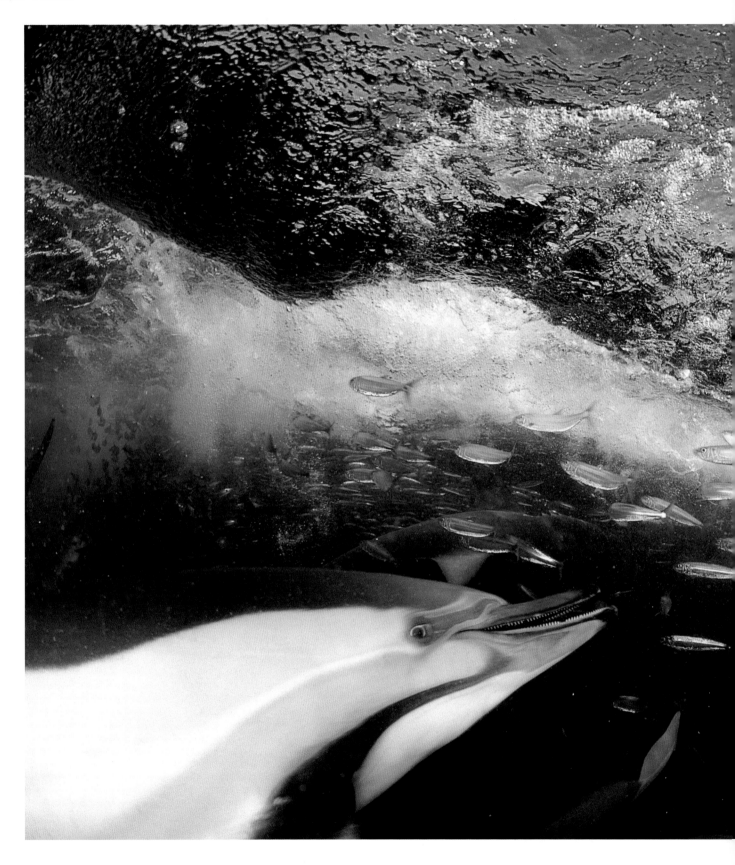

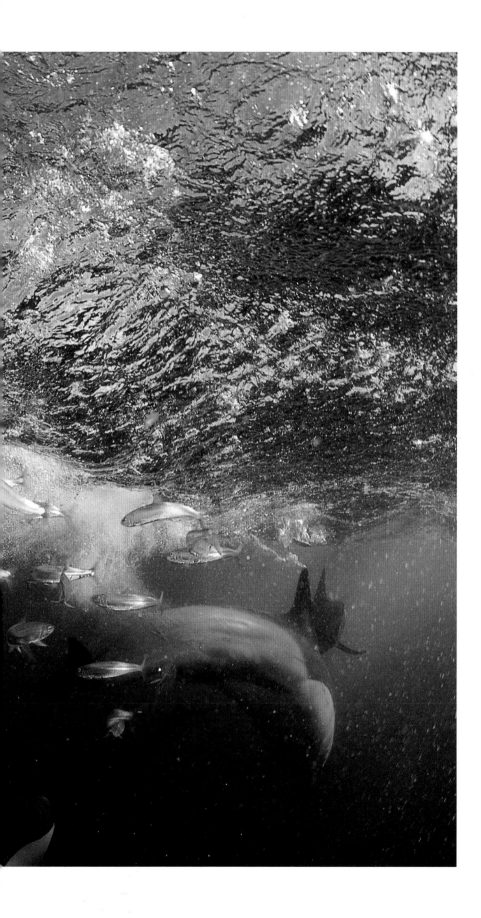

Sardine snappers

SPECIALLY COMMENDED

Thomas P. Peschak

SOUTH AFRICA

Each June and July, long-beaked common dolphins move into a tongue of cold water that licks South Africa's east coast, lured by the mass of migrating sardines. The dolphins hunt together and carve off 'baitballs' from the huge sardine slick. Some swim circles around the fish to herd them upwards, while others rush in to feed. The area becomes a bubbling cauldron, with bronze whaler sharks hunting alongside the hundreds of dolphins. To take this picture, Tom had to melt into the baitball and found himself surrounded by sardines desperate to hide from their attackers. 'The dolphins were catching fish just centimetres from my mask and camera,' he adds, 'yet they never once bumped into me.'

Nikon D2x + 10.5mm f8 lens; 1/250 sec at f8; ISO 100; Subal housing; two Inon strobes.

Eye of the beaver

HIGHLY COMMENDED

Laurent Piechegut

FRANCE

The signs of beaver industry were unmistakable:
freshly gnawed branches along the banks of a river
in Languedoc-Roussillon, France. So Laurent set
about looking for the lodge. He had seen
European beavers from the surface but never
under the water, in their realm. When he finally
located the tree worker, he donned wetsuit and
snorkel and slipped into the water. The shot was
taken as the beaver emerged from its resting place
under the bank. 'The face-to-face encounter was
a beautiful, powerful moment,' says Laurent, but
a brief one, as he moved aside to let the diligent
rodent get on with its work.

**Canon EOS 5D + Canon 15mm f2.8 fisheye lens; 1/80 sec
at f10; ISO 200; Seacam housing; two Ikelite DS
125 strobes.**

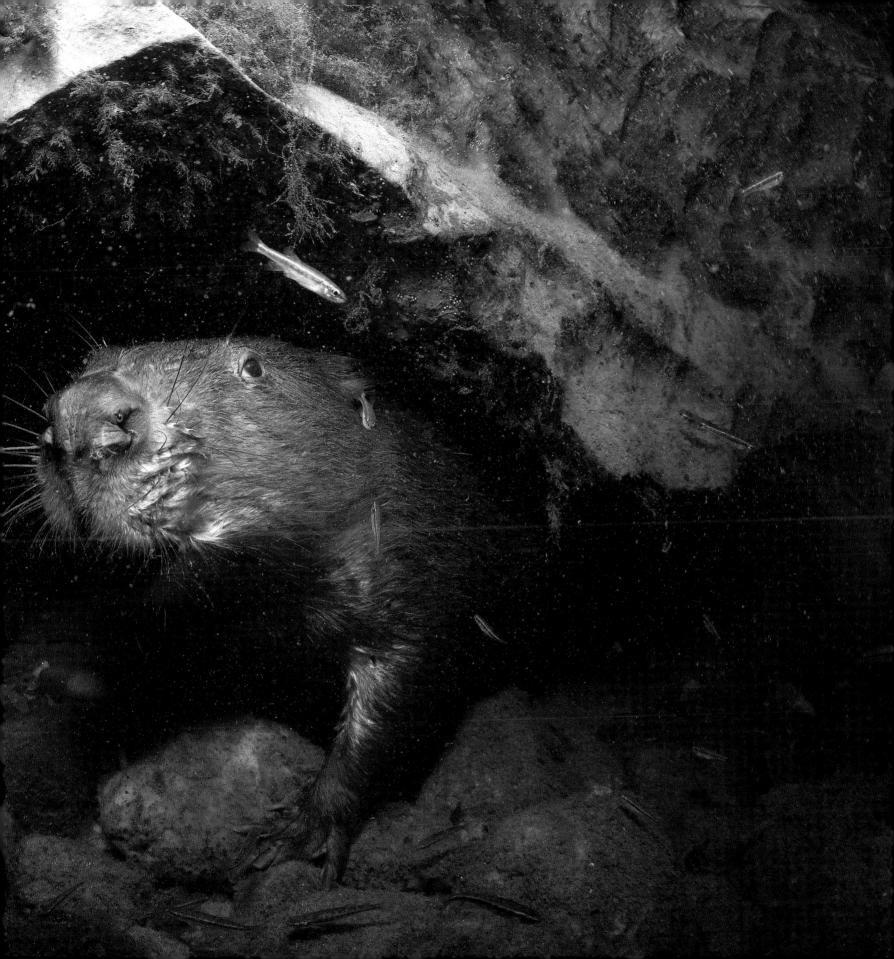

Soft-coral community

HIGHLY COMMENDED

David Hall

USA

'Soft corals are one of my favourite subjects,' says David, 'and this particular colony in Indonesia was unusually colourful.' A shy goby was living with the colony, and deciding to make it the focus of the composition, David waited patiently for it to show itself long enough for a few exposures. The goby depends on the coral for shelter, as do many small animals, including the transparent shrimps and ctenophores (comb jellies) that also appear – or disappear – in the picture. For them, the choice of lack of colour is driven by the need to camouflage themselves in their soft-coral home.

Canon EOS 5D + 100mm macro lens; 1/200 sec at f20; ISO 250; Subal housing; two Ikelite DS51 strobes.

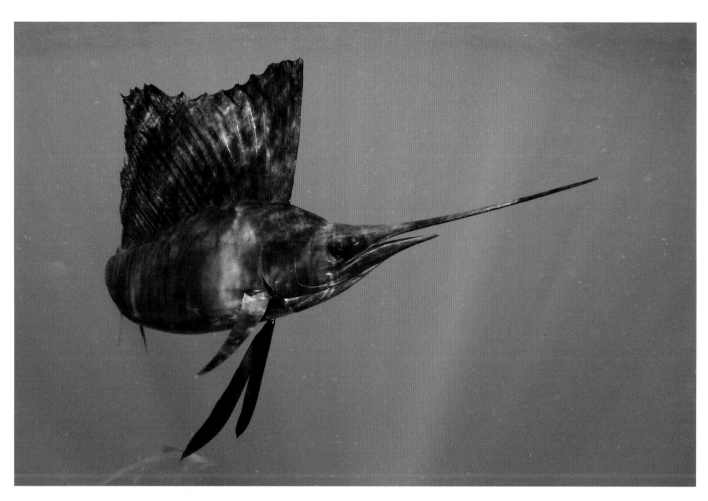

Sailfish sprinter

HIGHLY COMMENDED

Amos Nachoum

ISRAEL/USA

With a rapier bill and the nose of a jet, the sailfish is reputedly the fastest fish in the ocean, and as a celebrity fish, it is much sought after by game fishermen. The sport-fishing industry off Cancun, Mexico, is big business, but it now has an enforced catch-and-release policy. Amos hitched a ride on a game-fishing boat to shoot the champion sea sprinter hunting sardines. 'I was completely overwhelmed by the sailfish's abilities,' he says, 'its sheer beauty, grace and power.' He adds, 'When I showed the game fishermen my images, they were full of awe and gained new respect for the sailfish – and for the catch-and-release policy.'

Canon EOS-1Ds Mark III; 1/200 sec at f4; ISO 125; Seacam housing.

Colourful business

HIGHLY COMMENDED

Noam Kortler

ISRAEL

Fish that cruise past the Moses Rock, off the coast of Eilat, Israel, get a quick clean – whether they want one or not. 'A little cleaner fish will dart out and pick off a couple of parasites,' says Noam. Most big reef fish, though, make a point of turning up at the cleaning station for a daily grooming session, which can last several minutes. The cleaner fish advertises its identity and its services with its black-striped livery and a special jerky swim. But lurking in the background can be an impostor: a species that masquerades as a cleaner but snatches bits of scale instead of parasites. Here, a dazzlingly colourful bullethead parrotfish holds its mouth open so a cleaner can peck inside for titbits. Queues can form as reef fish wait their turn.

Nikon D2x + Nikon 105mm f2.8G VR micro lens; 1/125 sec at f13; ISO 100; Seacam housing; two Ikelite DS125 strobes.

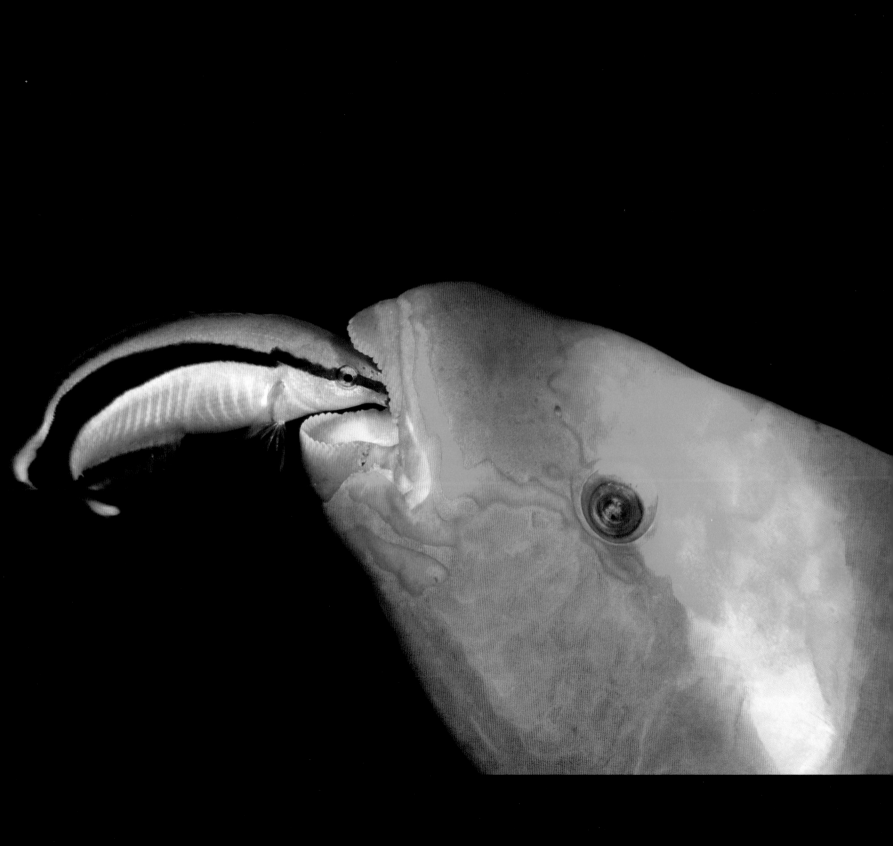

Animal Portraits

This category – one of the most popular in the competition – invites portraits that capture the character or spirit of an animal in an original and memorable way.

Troublemaker

WINNER
Stefano Unterthiner
ITALY

The home of Sulawesi black-crested macaques is the forest, and that was where the group that Stefano followed for weeks spent most of its time, in Tangkoko National Park in the north of the island. But when the macaques' search for food took them to the coastal edge of the forest, they ventured along the beach to scour the rocks for fallen fruits and nuts or, in the case of the young ones, to paddle in the waves. This young adult, nicknamed Troublemaker, was more interested in Stefano. So getting a close-up wasn't difficult. Handling Troublemaker's mischief, though, proved more of a challenge. 'He would leap at me and kick off my back like a trampoline,' says Stefano. 'It was part play, part confrontation, part attention-seeking, part curiosity.' Troublemaker's expression captures, Stefano says, 'the spirit of these wonderful monkeys', and the setting makes it an unforgettable portrait.

Nikon D2X + Nikon 12-24mm lens; 1/250 sec at f10; ISO 125; graduated neutral-density filter; flash.

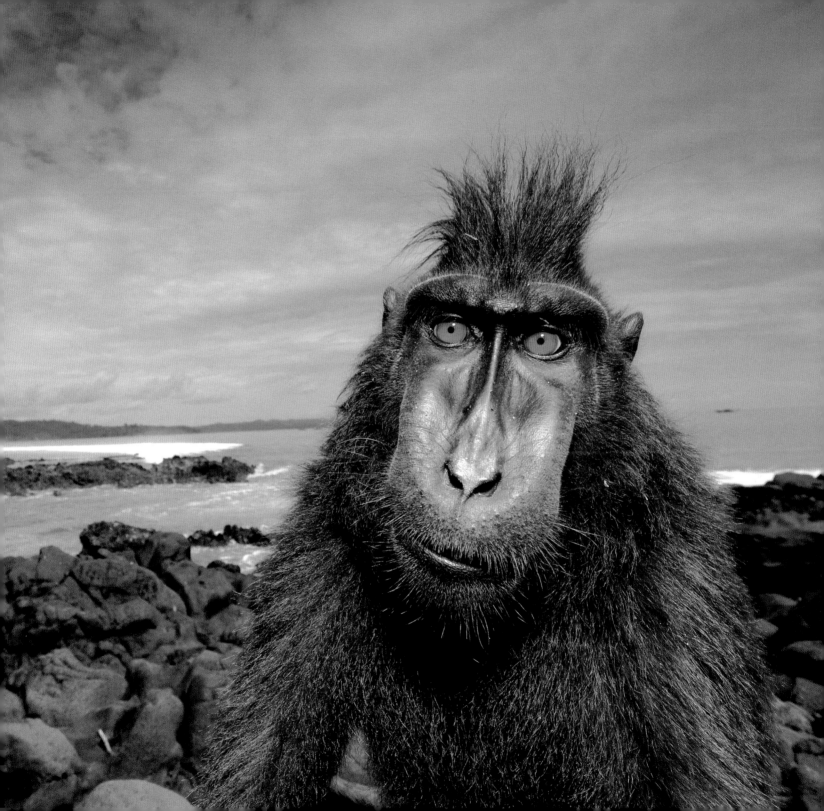

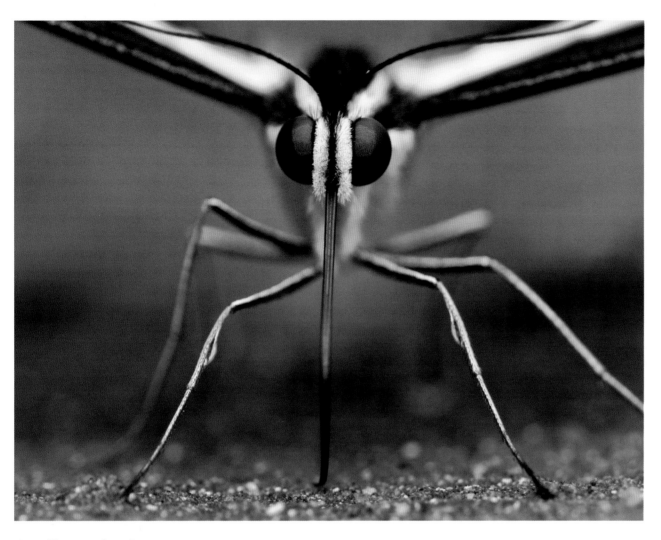

Swallowtail salt-sipping

SPECIALLY COMMENDED

Bill Harbin

USA

Resisting the temptation to show a giant swallowtail in its open-winged glory, Bill presents it at eye level. The butterfly was one of a group 'puddling' (imbibing salts from wet earth) beside a stream in Mexico. 'Looking through binoculars,' he says, 'I was struck by the power of the head-on image of its large black eyes, contrasting yellow face and long proboscis.' By crawling on his stomach through the mud and sand to within 30cm, he captured the dramatic perspective he wanted.

Canon EOS-1D Mark III + 180mm macro lens + 1.4 teleconverter; 1/125 sec at f9; ISO 400; Canon 580EX flash + ETTL2.

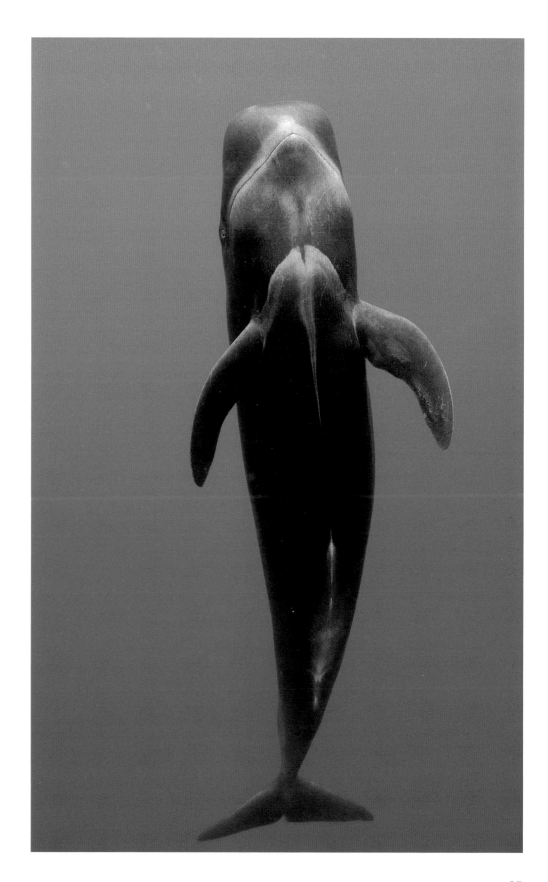

Curious calf

RUNNER-UP

Jordi Chias

SPAIN

Sailing one calm day off the Canary Islands, Jordi encountered a group of five short-finned pilot whales. Slipping into the water for a closer look, he found himself the centre of attention of a mother and her calf. For the calf, he was something new and curious. For its mother, he was a potential threat, and at first she kept herself between Jordi and her infant. But after a while, the mother lost interest and melted into the background. As soon as she did, the calf went straight up to Jordi. It stayed motionless just a metre from his lens. 'I took a few shots,' says Jordi, 'but then I lowered my camera and simply looked the calf in the eye – a moment I will never forget.'

Nikon D70s + Nikon 12-24mm lens at 18mm; 1/80 sec at f5.6; ISO 200; Hugyfot housing; no strobes.

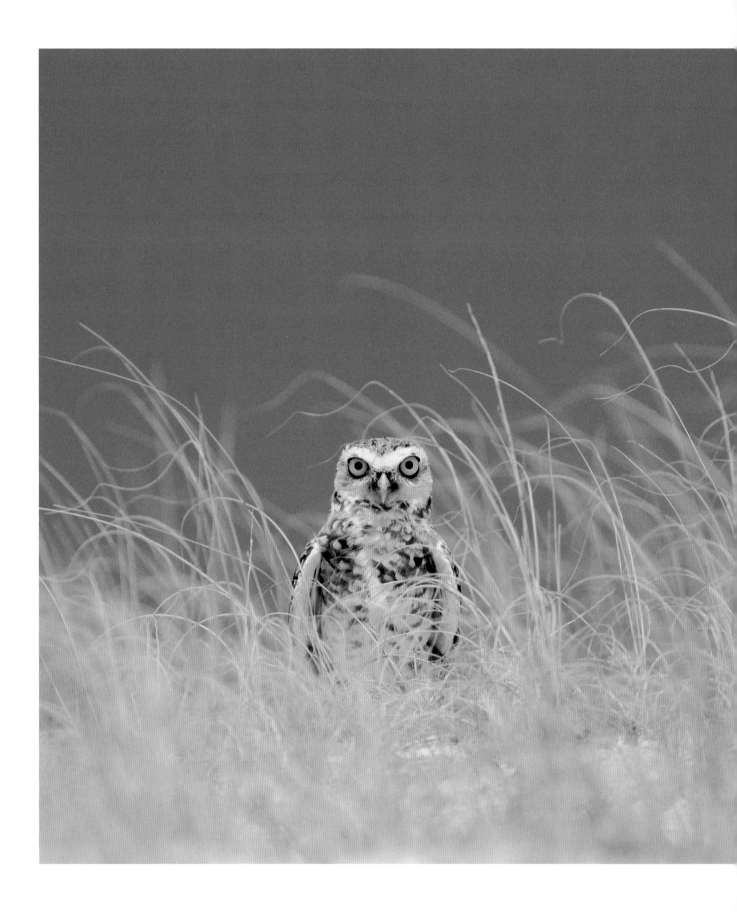

Owl glare

SPECIALLY COMMENDED

Adriano Ebenriter

BRAZIL

Adriano set out in the early morning for the sand dunes on the island of Florianópolis, southern Brazil, to photograph burrowing owls. They have excellent eyesight and can spot an approaching human from a long way off, but Adriano has discovered that walking backwards towards them is one way to get close. That morning it took quite a time before he located any owls – a pair on guard near their burrow. Carefully positioning himself so that the birds were well lit, he waited till one of them posed on the top of a dune watching the photographer, now lying prone. Adriano shifted himself to where there was an opening in the wind-blown grass, allowing him to frame the owl against the blue sky. 'I then complied with the owl's obvious glaring demand,' says Adriano, 'which was to get off its patch, now.'

Nikon D70s + 80-200mm f2.8 lens at 200mm; 1/3200 sec at f5.6; ISO 400.

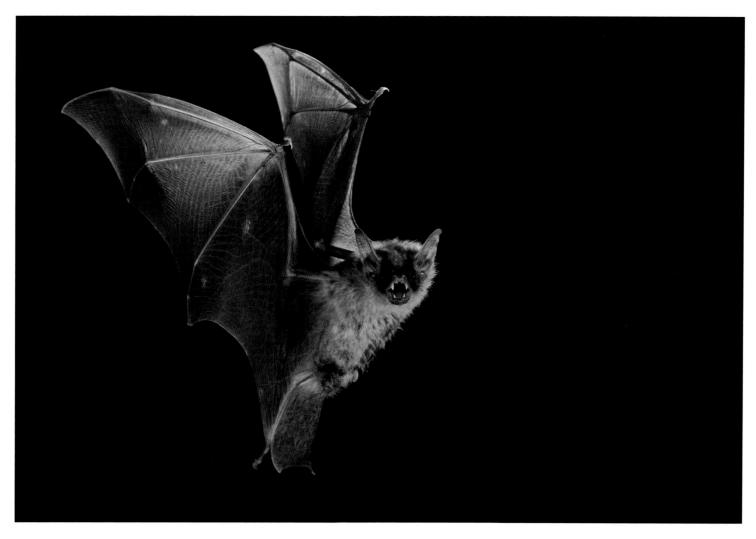

Flight of the mouse-eared bat

SPECIALLY COMMENDED

Carsten Braun

GERMANY

Carsten's shot was taken in a cave near Mayen, Germany, where he was helping scientists catch and ring greater mouse-eared bats (a threatened species in Europe and extinct in the UK). As the scientists finished measuring and ringing them, Carsten photographed the bats' release. 'In such conditions,' explains Carsten, 'flash control was crucial.' The aim was 'to get the bat not only in focus and softly lit, but in the right position'. The challenge was to set up the cameras, flashes and cables in the right place in the pitch darkness of the cave with just the aid of a head-torch.

Canon EOS 5D + 70-200mm f2.8 lens; 1/200 sec at f16; ISO 100; four Canon 550EX flashes + light-beam sensor.

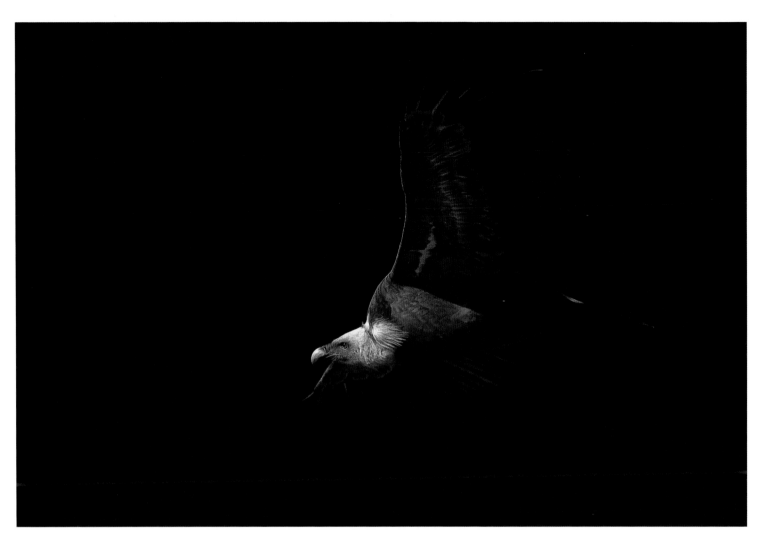

Griffon glide-by

HIGHLY COMMENDED

Juan Manuel Hernández López

SPAIN

The River Duratón has gouged deep gorges out of Segovia's limestone, and in the Hoces del Rio Duratón Natural Park, choughs, peregrines and kites soar and swoop through the canyons. On the cliffs is a breeding colony of griffon vultures, some 400 or 500 of them. Manuel is fascinated by these giants, and his favourite perch is on the cliff-edge, close enough to eyeball the vultures as they rise on updrafts of warm air. 'As this griffon glided past, its head spotlit by the sun, I could hear the 'whoosh' of its massive wings,' says Manuel.

Nikon D70s + 400mm lens; 1/1600 sec at f5.6; ASA 200.

Angry queen

HIGHLY COMMENDED

Piotr Naskrecki

POLAND

You don't need to be another ant to get the queen's message. 'She is bending her abdomen forwards, ready to spray me with formic acid,' Piotr explains. Armoured ants, as their name suggests, are equipped with exceptionally hard exoskeletons, and sharp spines cover the thorax. During a biological survey in Cambodia's Virachey National Park, Piotr spotted this newly mated queen crawling through the leaf-litter, looking for somewhere to start a new colony that will eventually be thousands strong. 'She had already lost the wings she used for her nuptial flight,' he says. Her shiny armour glinted in the sun, and so Piotr placed a portable 'diffusion box' over her to smooth out the lighting. The ant soon made her feelings clear. So Piotr released her to go forth and multiply. And multiply . . .

Canon EOS-1D Mark II + Canon MP-E 65mm macro lens; 1/160 sec at f16; 400 ISO; Canon MT-24EX and two Canon 580EX flashes + small diffusion box.

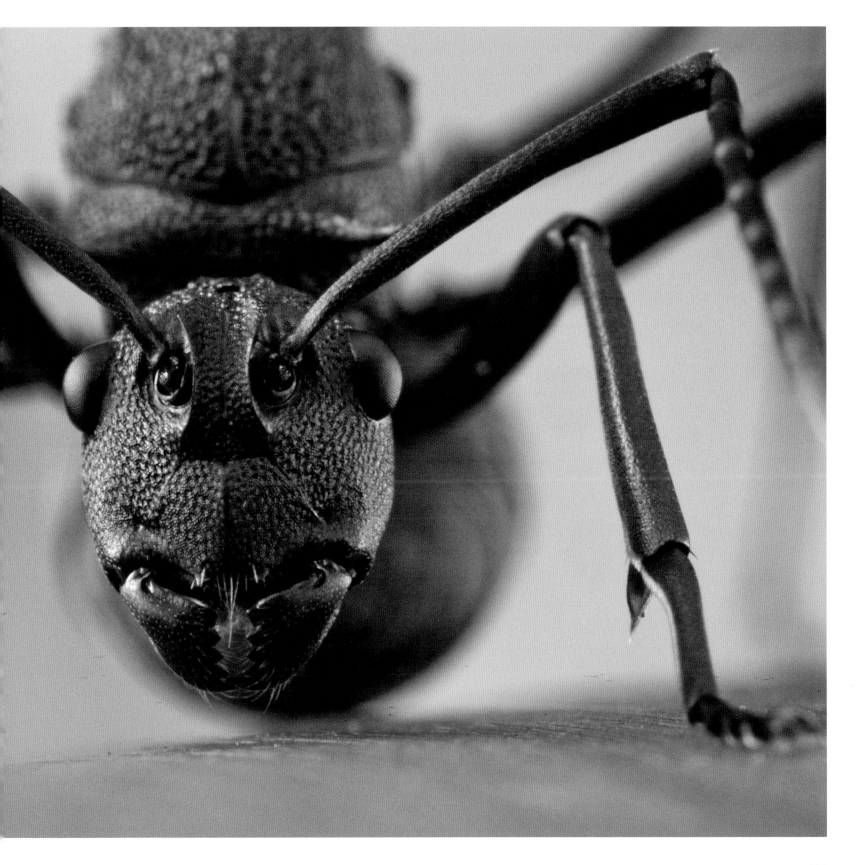

Car-park robins

HIGHLY COMMENDED

Andreas Byrne

UNITED KINGDOM

An elegant Edwardian house near Salcombe, south
Devon, was home to scientist, collector and
inventor Otto Overbeck until 1937. Now it belongs
to the National Trust and is open to the public –
which, of course, means tea-rooms and car parks.
As soon as Andreas arrived, two robins landed on his
car aerial and then hopped up to him. By twisting
up the screen on his camera, he was able to see
the image in the viewfinder without having to lie
flat on his stomach. 'I put it on its widest setting,
and one robin hopped to within a foot of it.'
Thus a strip of tarmac proved to be as rewarding,
photographically, as Overbeck's exotic gardens.

**Canon A620 compact + fixed zoom lens; 1/50 sec at f8;
ISO 100.**

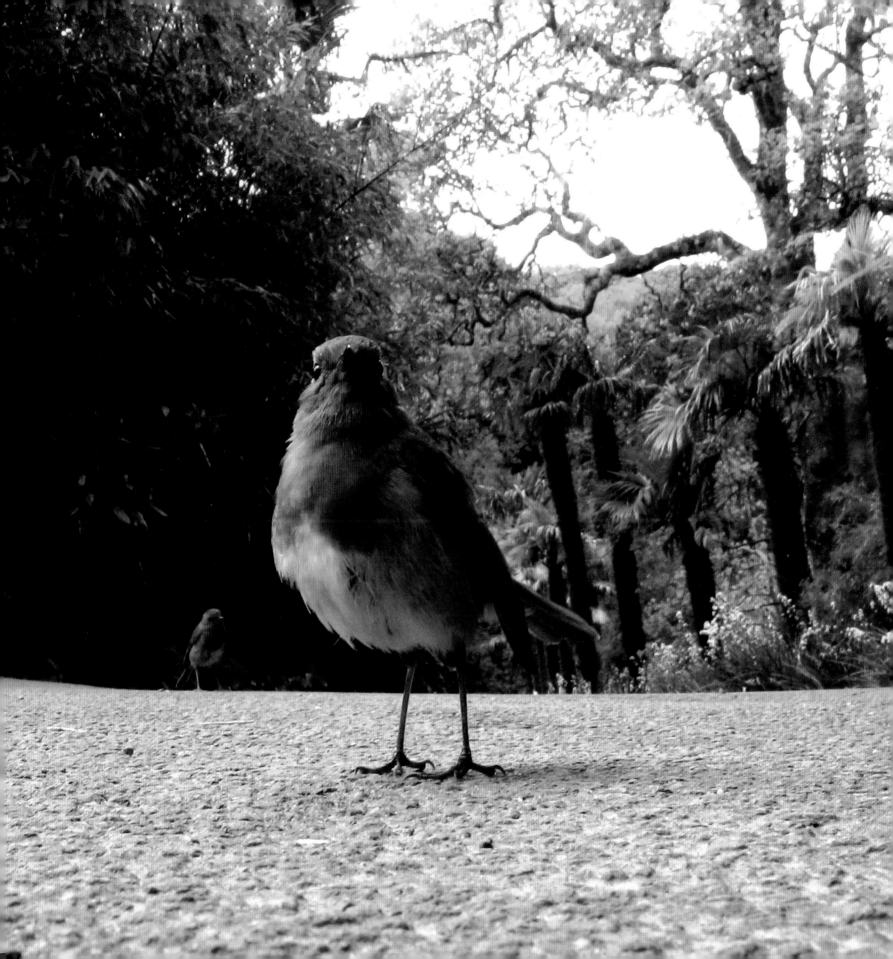

Big baby nap

HIGHLY COMMENDED

Claudio Contreras Koob

MEXICO

Claudio spent some time on Guadalupe Island,
off the Pacific coast of Baja California, Mexico,
photographing the wildlife of this biosphere
reserve as part of a major scientific project.
It was April, when the elephant seals abandon
their pups to fend for themselves. The young pups
spend most of their time basking in the sun
between small forays into the water to learn
the necessary skills for a life on the high seas.
It's a dangerous time, as big, plump babies with
limited swimming skills attract great white sharks.
Claudio watched this elephant seal 'weaner'
splash around in the surf and then haul up onto
the beach and fall sound asleep, giving him
the opportunity to take this graphic image.

**Canon EOS-1Ds Mark II + Canon 300mm f2.8 IS USM lens
+ 2x II extender EF; 1/60 sec at f10; ISO 200; Gitzo tripod.**

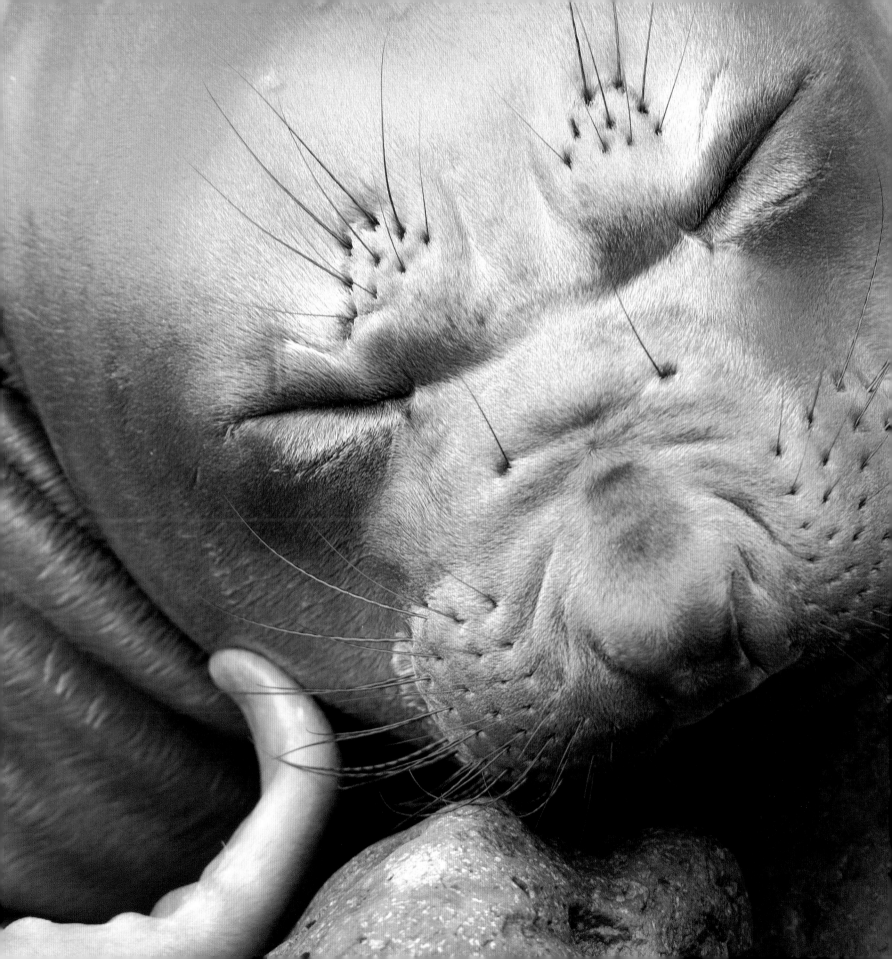

Grouper grab

HIGHLY COMMENDED

Aaron Wong

SINGAPORE

Just as Aaron was about to descend on an evening dive, a feeding frenzy broke out. Tourists on a nearby boat had begun tossing bread in the water, and now surgeons, wrasses and small jacks were all fighting for a share. The reef fishes off the tropical island of Tioman, on the east coast of Malaysia, are used to the arrival of tourist boats and had come to the surface in anticipation. Some were even snatching food right out of people's fingers. 'With the sun setting, I knew there was the potential for a good sun-burst shot,' says Aaron, who hovered at the surface waiting for the right moment. 'This little grouper was darting after bread,' he says. 'Getting a fast-moving, small fish in pin-sharp focus at close range was extremely difficult. I took as many shots as I could, limited only by the recycle time of my twin strobes. It was a case of hit or miss during such fast action.' Aaron spent about 20 minutes near the surface before descending for his dive. 'I didn't even realize I got the shot until I was back on the boat,' he says.

Nikon D70 + Nikon 10.5mm lens; 1/160 sec at f11; ISO 200; Sea & Sea housing; two Sea & Sea YS90 strobes.

Bee-eater ballet

HIGHLY COMMENDED

Chris van Rooyen

SOUTH AFRICA

A boat moored on the Zambezi was the perfect hide from which to observe the colony. At least 1000 carmine bee-eaters were breeding in this area of riverbank, in Caprivi, Namibia – one of the largest colonies in southern Africa. Whenever a loitering raptor drifted too close, a burst of carmine would explode from the numerous burrows. Activity was constant, and the birds never stopped chirruping to each other as they chased insects. 'I had the distinct impression some were just having fun,' says Chris. 'They would weave around in the wind, hover in the updraft created by the riverbank, and then fold their wings to parachute back into the nest-hole.'

Canon EOS-1D Mark II + Canon EF500mm f4 IS USM lens + 1.4 II teleconverter; 1/2500 sec at f8; ISO 400; Manfrotto 055CL tripod + 501 friction head.

Wild Places

This is a category for landscape photographs, but ones that must convey a true feeling of wildness and create a sense of awe.

Skeleton Coast

WINNER
Andy Biggs
USA

Andy peered through the scratched airplane window and wondered how he could convey the giddy heights of the Namibian sand-dunes. He didn't have long to decide. The dense sea-fog from the cold Benguela Current was being sucked inland over the Skeleton Coast, and the sun would soon sizzle it away. But for an hour the fog draped over the endless sandy crests and corrugations. 'I wanted to capture the way shafts of sun piercing through the mist highlight the textures of the sand,' says Andy. The huddle of Cape fur seals – a dark smudge on the narrow strip of beach – give a sense of the vastness of this wilderness.

Canon EOS 5D + 24-105mm lens at 47mm; 1/1250 sec at f5.6; ISO 500

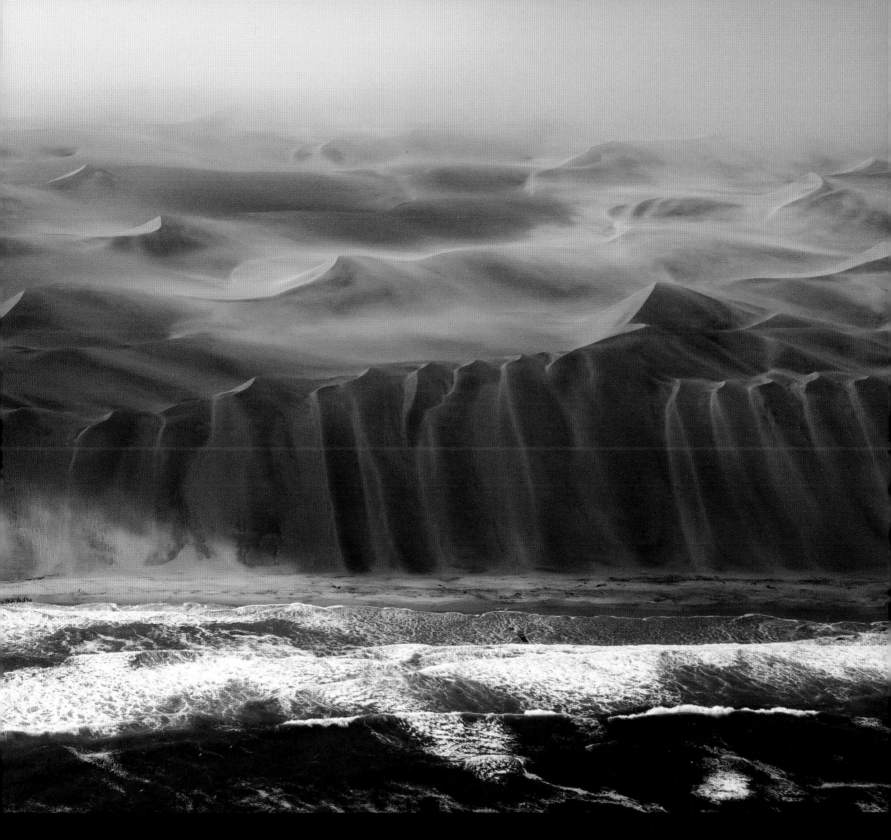

Moonrise over the Badlands

RUNNER-UP

Franz Josef Kovacs

AUSTRIA

The Bisti Badlands is an extraordinary landscape of colourful eroded rocks in the northwest corner of New Mexico, USA. A geologist's dream, the multicoloured formations are made from fossil-embedded layers of coal, silt, shale and mudstone combined with sandstone. 'I had a full week', says Franz, 'to scout the landscape and find my favourite composition' before the full moon. The shot he wanted was the moon rising over the desert horizon, but when it came to the moment, he had just 'one minute when the shadows and the pink afterglow were perfect' and managed to take just two images of the glorious scene.

Linhof Technikardan 45s + 4x5 Schneider Apo-Symmar 210mm f5.6 lens; 8 sec at f22; Fuji Velvia 50; 0.6 + 0.9 hard-graduated neutral-density Lee filter; Gitzo tripod.

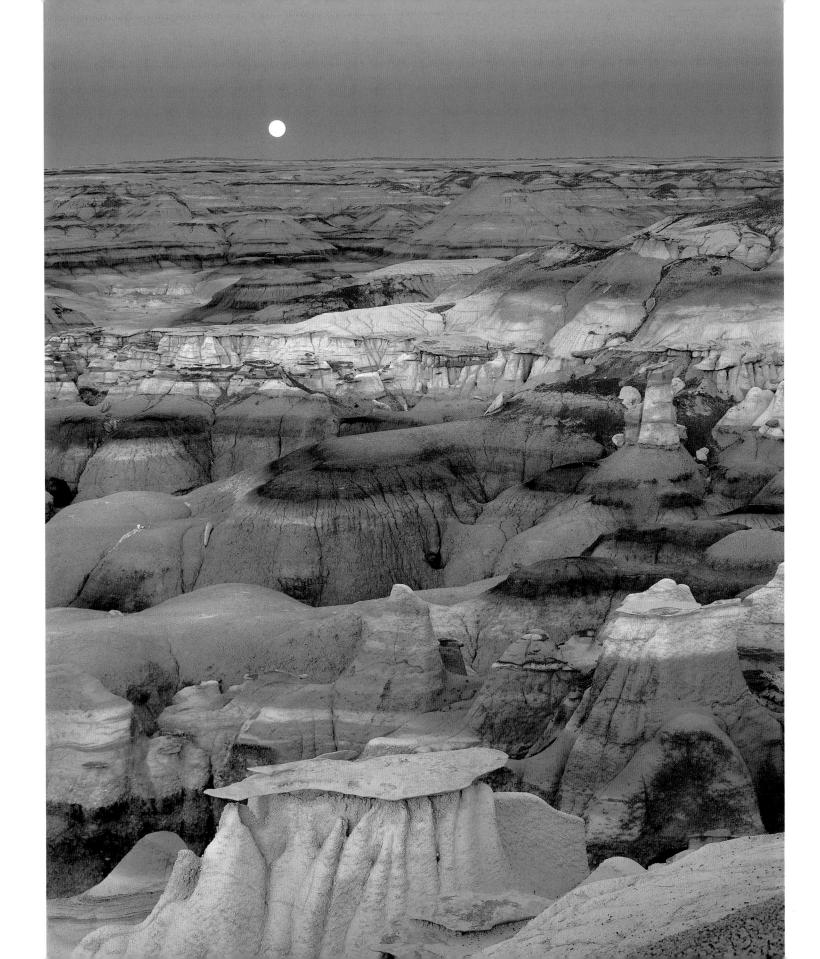

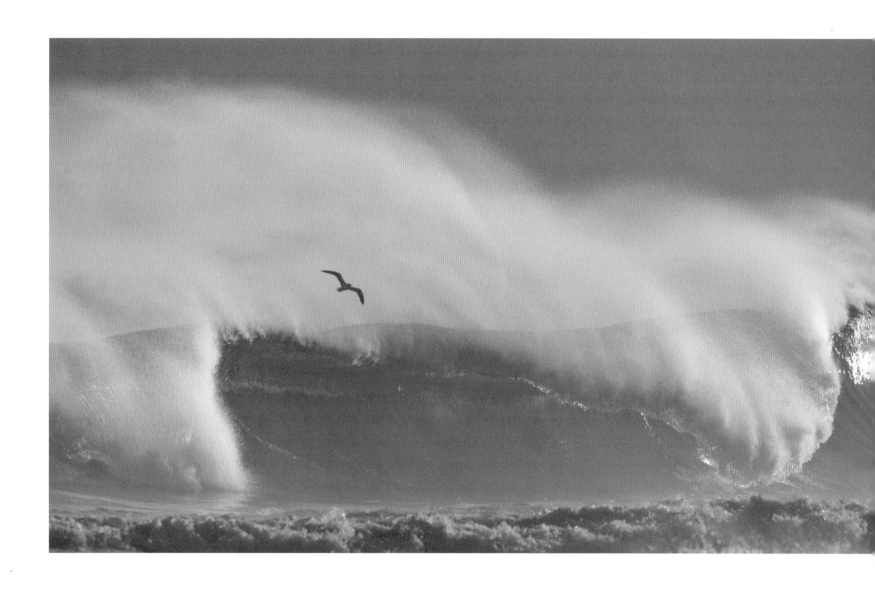

Wild waves

SPECIALLY COMMENDED

Albert Froneman

SOUTH AFRICA

Following a cold front, massive waves battered the coastline of Robberg Nature Reserve in South Africa's Western Cape. Albert was impressed by the sheer size and energy of the waves and set out to capture the dynamic scene. 'The late afternoon light made them look translucent,' he says, 'and the wind whipped off huge sheets of sea spray as the waves kept crashing in.' A kelp gull, snatching fish from the surface between waves, flew across the blue-grey scene at the ideal moment, giving a sense of scale and a focal point.

Canon EOS-1D Mark II + Canon EF500mm f4 IS USM lens; 1/4000 sec at f8; ISO 400.

Urban and Garden Wildlife

These pictures must show wild plants or animals in an obviously urban, suburban or garden environment.

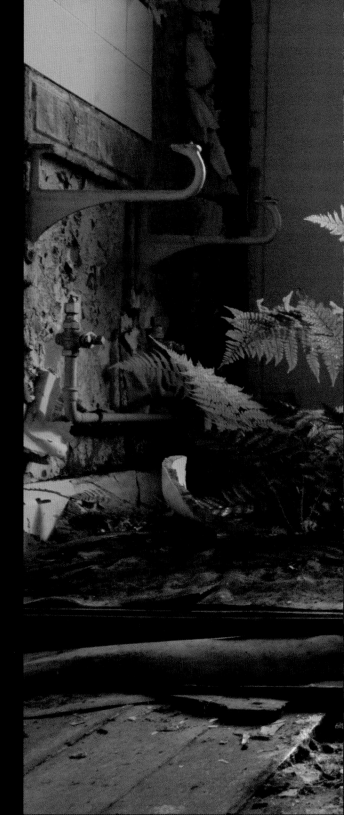

New occupant

WINNER

Jamie McGregor Smith

UNITED KINGDOM

As part of a social-change photographic project, Jamie visited a derelict asylum in Kent that had been closed down for many years. 'After flashing my torch through dark stairwells and overcoming my own self-induced paranoia,' says Jamie, 'I came to an old bedroom.' Peering round the door, he was immediately struck by the fresh fern fronds, backlit by sunlight streaming through the window – in stark contrast to the rest of the contents of the grim, drab room. Against all odds, the fern was thriving, gaining nourishment from the decomposing floorboards. 'The Bakelite phone and broken sink are poignant reminders of how the space was once occupied by people,' adds Jamie. 'But now the space belongs to the fern.'

Canon EOS 20D + Sigma 18-200mm f3.5-6.3 DC OS lens;
8 sec at f22; ISO 100.

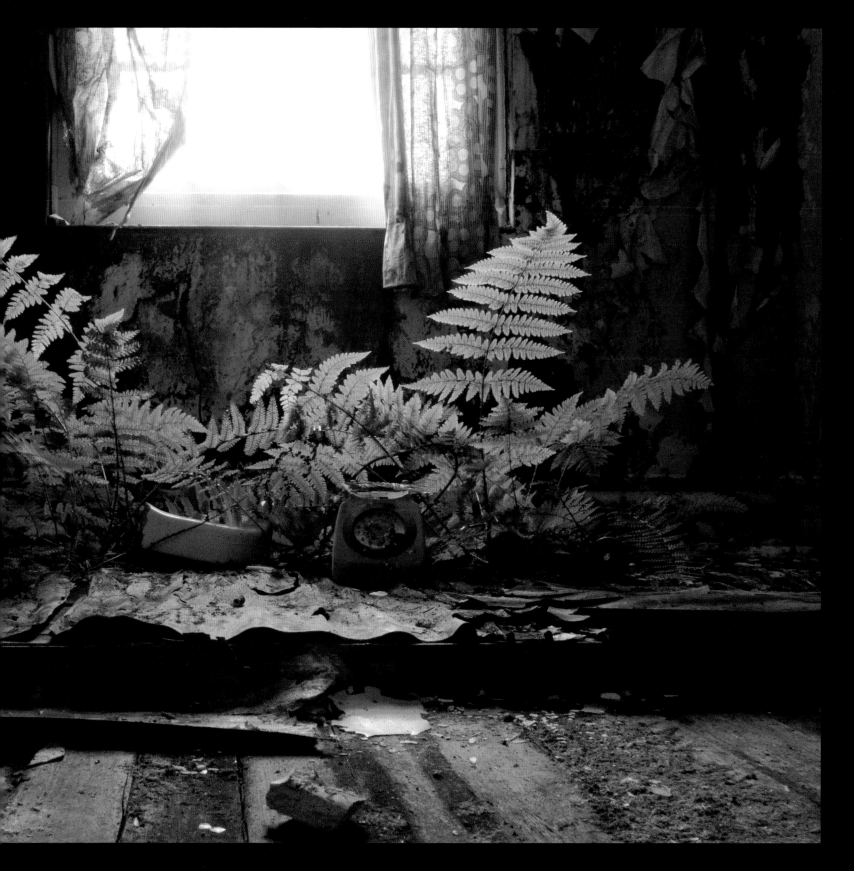

One Earth
Award

Pictures entered must highlight
in a thought-provoking and
memorable way our interaction
with the natural world and our
dependence on it.

Sacrifice

WINNER

David Maitland

UNITED KINGDOM

In a gory backstreet courtyard in Libreville, thick
with plucked porcupine quills and scrapings of
flesh, David watched as a woman prepared an
endangered Gabon black colobus monkey for sale.
'It was tossed onto an open fire to strip off the
fur,' he says. 'A cloud of acrid smoke filled the air.
Then the glossy jet-black fur caught fire, crinkled
and crisped up, and fell off as dust. It was deeply
upsetting.' Trading in bushmeat is banned in
Gabon, but David saw turtles, crocodiles,
porcupines and monkeys openly on sale. Along
with logging, the bushmeat trade threatens the
country's wildlife. Though the animals David saw
on sale appeared to be for local consumption, that
might soon change. In a potential $4.9 billion deal,
Gabon has agreed to allow China to mine iron ore
over 7,000 square kilometres of forest bordering
Ivindo National Park in the Belinga Mountains.
'The huge labour force could be a significant
consumer of bushmeat,' says David, 'and the
potential impact on wildlife is very worrying.'

Canon EOS-1Ds Mark II; 16-35mm f2.8 lens at 16mm;
1/30 sec at f8; ISO 100.

Window on the ice melt

RUNNER-UP

Ira Meyer

USA

'I love ice – the astounding shapes and forms it creates,' says Ira, a self-confessed ice-aholic who has journeyed to the polar regions eight times. In August 2007, he travelled as photographer-in-residence on a passenger ship sailing to the Arctic. When the ship dropped anchor off east Greenland, he had a chance to photograph the ice from a Zodiac. 'The arch in this 50-metre iceberg was spectacular,' says Ira. But he points out that such melting icebergs are also unpredictable. They can roll, implode and crumble with little warning. And the beauty of the ice belies something else – that the Arctic ice cover is shrinking as the temperature warms. The recent summer ice cover has been the lowest on record, and scientists have forecast ice-free summers in the Arctic within the next 30 years and possibly by 2014.

Canon EOS 20D + Canon 100-400mm f4.5-5.6 IS USM lens; 1/2000 sec at f5.6; ISO 200.

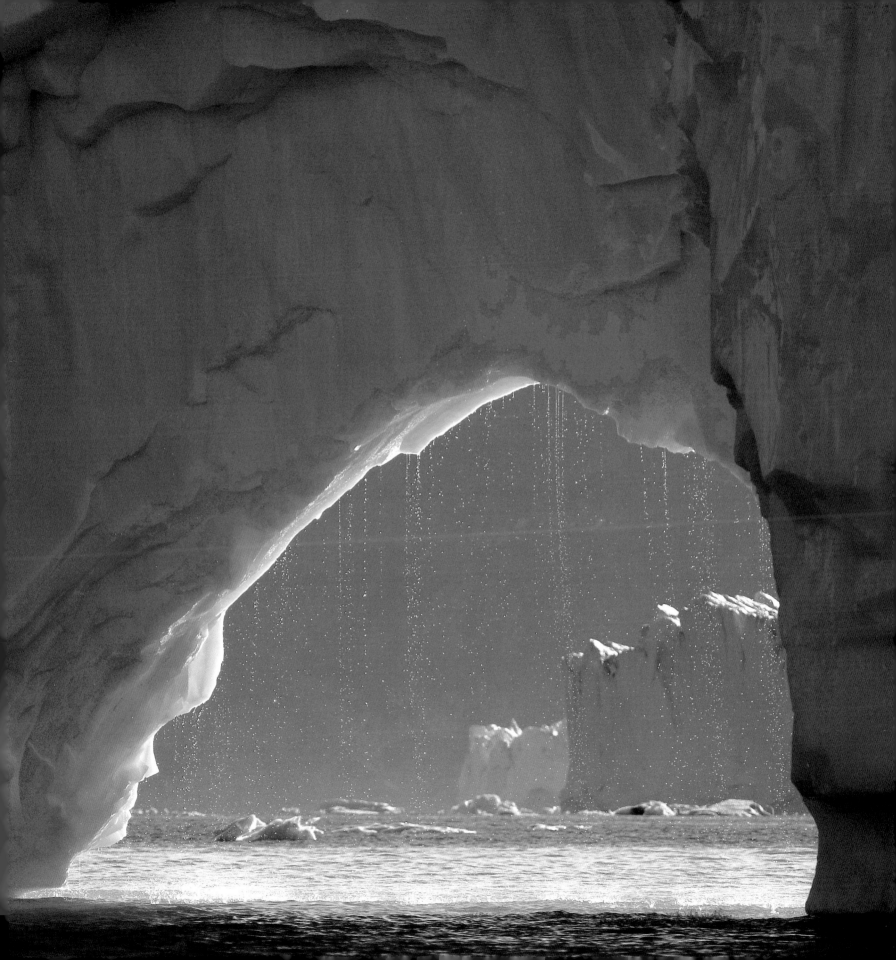

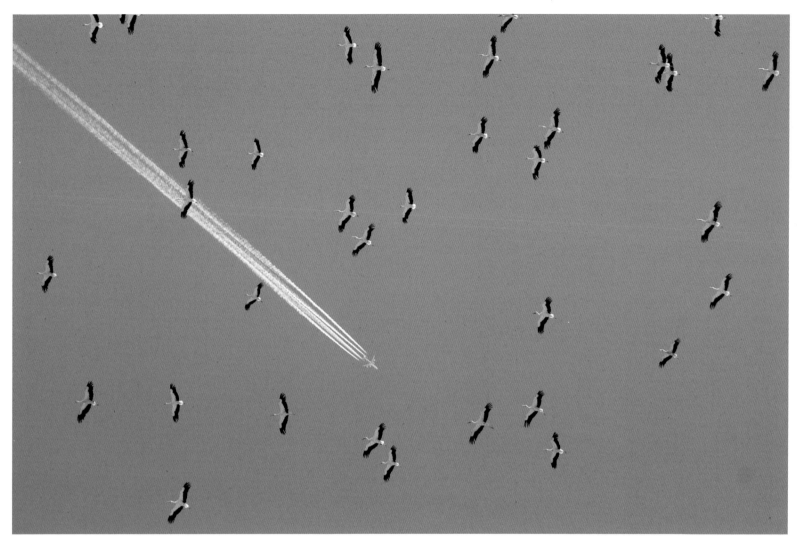

Flight-paths

HIGHLY COMMENDED

Martijn de Jonge

THE NETHERLANDS

The waste-tips of Spain are vital feeding stations for migrants such as white storks as they head south to their wintering grounds. The pickings are so good that some even choose to stay in Spain for the winter rather than continue south. One hot August morning, Martijn drove to a tip in Extremadura. As the first storks flew overhead, an aircraft flying north slashed across the azure sky far above. Martijn waited for the moment when the paths of the migrants crossed and took this shot 'to illustrate the contrast between human and bird migration'.

Nikon D2x + 24-85mm lens at 85mm; 1/1000 sec at f6.3; ISO 320.

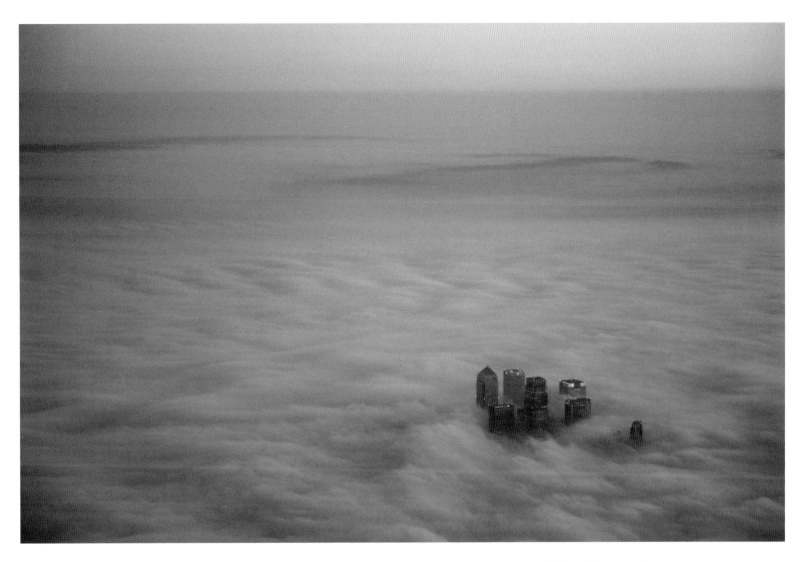

City descent

HIGHLY COMMENDED

Piers Calvert

UNITED KINGDOM

Looking down as his plane circled London was like watching a scene from a movie, recalls Piers, who had been taking pictures since his plane started to cross the Channel and the sun started to rise. 'It was extraordinary to see famous buildings, from the Gherkin to the Canary Wharf towerblocks, poke out through the blanket of fog.' But the contrast between the grand skyscape of pink sky and blue clouds and the emerging concrete structures made his heart sink as he realized the plane would soon descend into the greyness below.

Canon EOS 5D + 24-105mm f4 lens; 1/100 sec at f4; ISO 1600.

Gerald Durrell Award for Endangered Wildlife

The subjects photographed for this award are species that are officially listed as critically endangered, endangered, vulnerable or at risk, and the purpose of the award is to highlight the plight of wildlife under threat.

Snowstorm leopard

WINNER

Steve Winter

USA

It had been ten months since he had begun the quest in the mountains of Ladakh's Hemis High Altitude National Park. Using remote-controlled cameras placed along the Husing Trail, Steve had taken a number of pictures of snow leopards between January and July, but the shot he was after eluded him: a snow leopard in a snowfall with a backdrop that conjured up the atmosphere of its extreme environment. 'As the weather turned warmer, I moved the traps to higher altitudes along the trail,' he says. 'I put a camera in this location because it was where three trails converge.' The winter of 2007 was bitterly cold with hardly any snow, and he began to run out of hope. But on checking his camera one freezing May morning, he found this snow leopard gazing back at him exactly in the place in the frame he had hoped it would be. 'I was thrilled to have finally captured the shot I had dreamed of – a wild snow leopard in its true element.'

Canon EOS Rebel XT + 10-22mm lens at 16mm; 1/200 sec at f16; ISO 100; waterproof camera box + Plexiglass tubes for flashes; Trailmaster 1550-PS remote trigger.

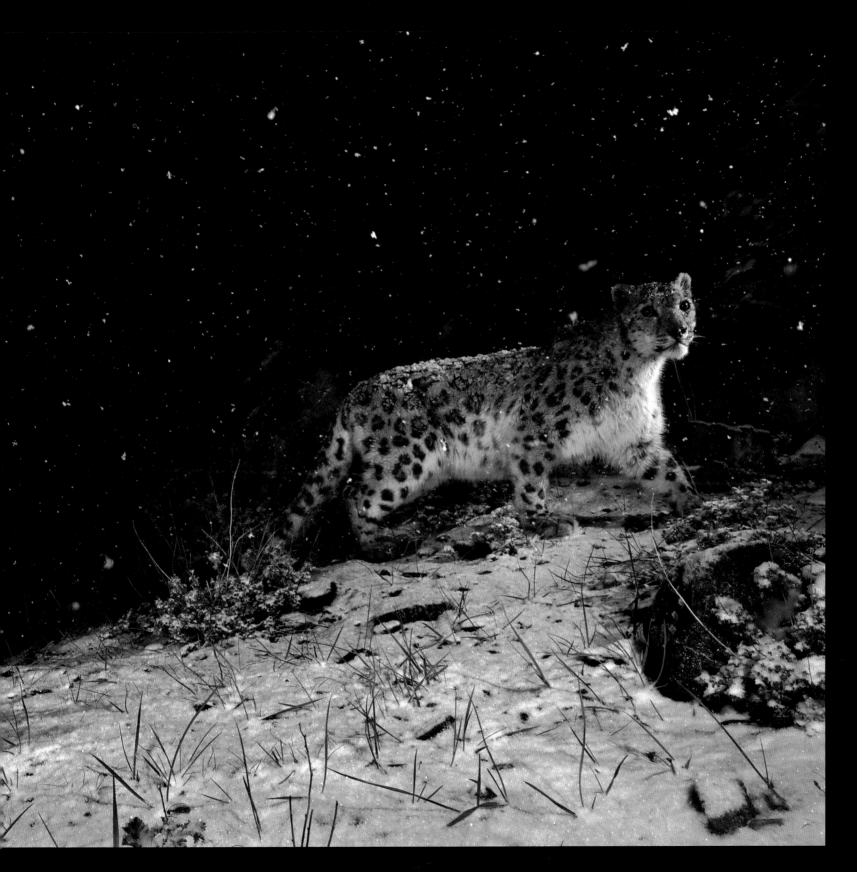

Bleak outlook

RUNNER-UP

Stefano Unterthiner

ITALY

A smelly T-shirt and hands-off approach helped
Stefano get close to the endangered Sulawesi
black-crested macaques as he followed them on
their foraging trips. He wanted to show them in
one of their last refuges, the dark primary
rainforest of north Sulawesi's Tangkoko National
Park, Indonesia. 'I didn't wash my clothes for
several days,' he says, 'so I could pick up the smell
of the troop and start to be accepted as a follower.'
After a couple of weeks, the macaques began to
approach him. Then one day, when he was sitting
watching them, one reached out and touched his
hand. Another macaque came and groomed him –
a sign of social acceptance. That close, Stefano
could see every eyelid flicker, every wrinkle, every
facial nuance. This young adult was particularly
curious, and with the use of a wide-angle lens and
the knowledge of what a respectful distance was,
Stefano was able to take the portrait he wanted.
'It was such a privilege,' he says. 'Their expressions
convey so much.' But the macaques' days are
numbered. Poaching and forest loss and
fragmentation have halved the population in
the past ten years, and the Sulawesi macaques
are now at high risk of extinction.

**Nikon D2x + Nikon 12-24mm lens; 1/100 sec at f10;
ISO 250; flash.**

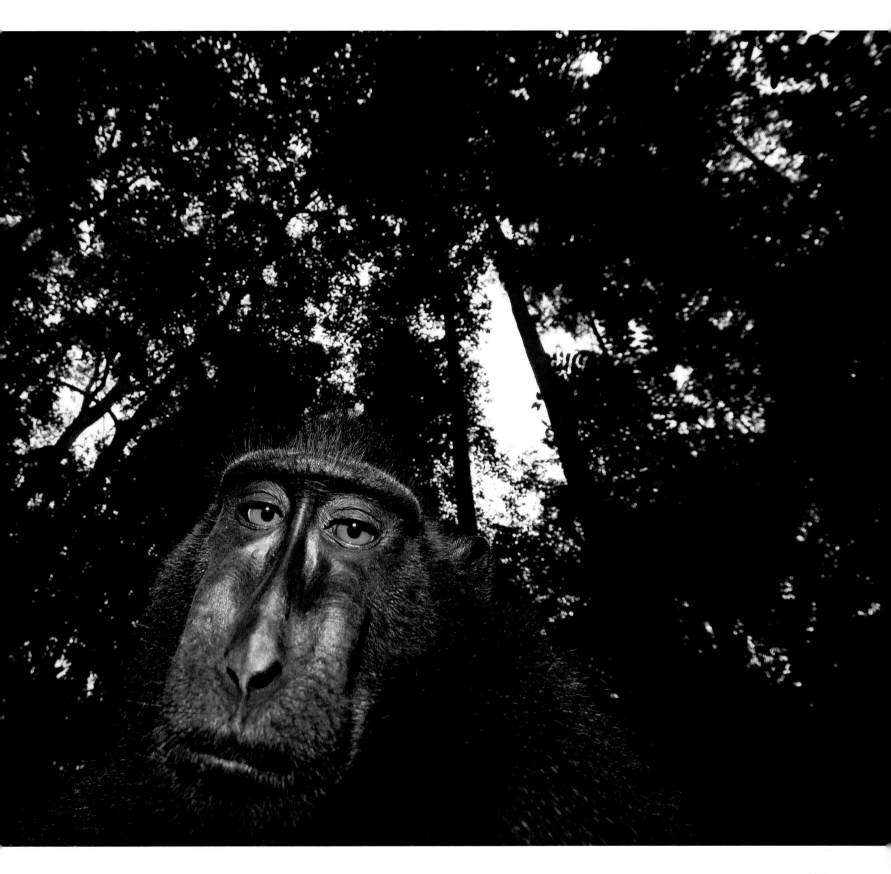

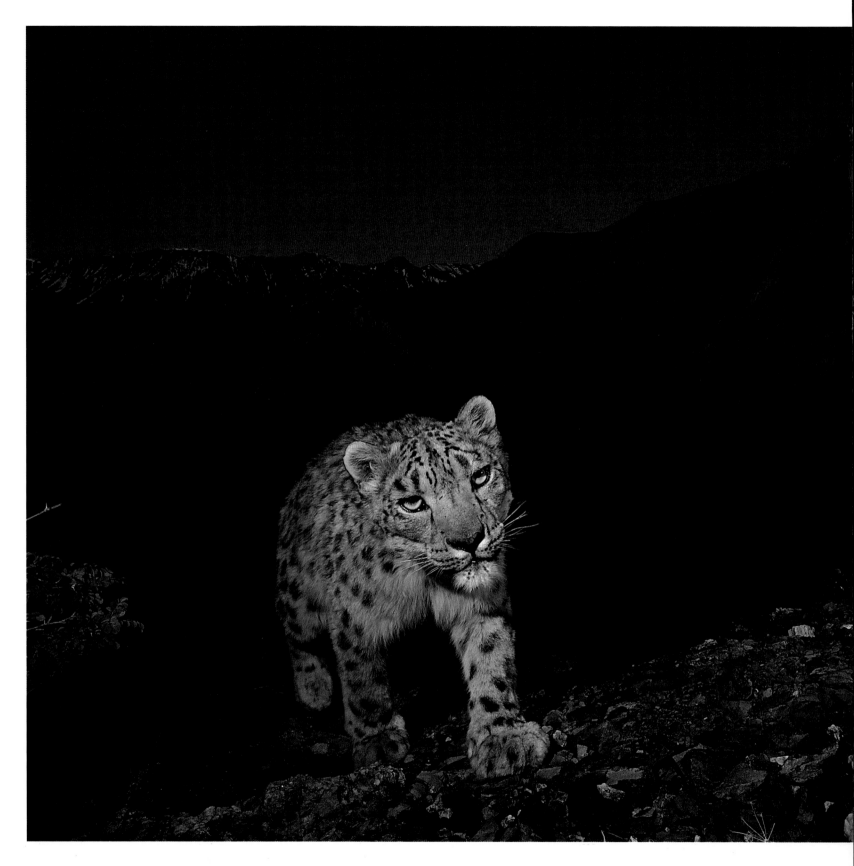

Mountain prowl

SPECIALLY COMMENDED

Steve Winter

USA

Choosing high-ridge locations to set up remote cameras made his life tough, especially with the altitude and the steep, difficult terrain. But Steve had a better chance of photographing the snow leopards here, because there were lots of signs (scrapes and spray marks) that the ridge was being well used. 'Part of that ridge was very narrow,' says Steve, 'so I set a camera in a location where the cat had no choice but to walk directly in front of it,' and in a position where, with luck, the cat would be in focus and 'the beautiful expanse of the Himalayas would be the backdrop.' Easier said than done. The cat had to be walking in the right direction and at the right time of day to get the blue sky. 'It took four months to get one photograph,' says Steve. 'This is the first of a five-frame set of photographs, but is the only one where the flashes fired.'

Canon EOS Rebel XT + 10-22mm lens at 13mm; 1/200 sec at f18; ISO 100; waterproof camera box + Plexiglass tubes for flashes; Trailmaster 1550-PS remote trigger.

On the big-cat trail

SPECIALLY COMMENDED

Steve Winter

USA

As this snow leopard strolled along the Tarbun Trail, high in the Indian Himalayas, the setting belied the fact that it was February and -40°C. 'It was shot in a riverbed in one of the few places in Hemis National Park where vegetation can survive,' says Steve. 'Local biologists had told me that the cat walked through this valley, and so I searched for a location which would create the composition, regardless of whether the cat would be walking toward the camera or away.' In fact, much of the beauty of the picture is that the leopard *is* walking away, relaxed and displaying its extraordinary tail – the longest of any cat's, used as 'a perfect balance aid in such a sheer environment' as well as a body-warmer. The wild rose, which scented the trail, adds an element of colour to what is normally a barren environment. The snow leopard is at the top of the food chain, influencing the mountain grazers and therefore the mountain vegetation. Lose the snow leopard, and the environment will change for ever. Today, the snow leopard is at crisis point, hunted as a predator of livestock but also for its luxurious coat and its bones.

Canon EOS Rebel XT + 10-22mm lens; 1/200 sec at f16; ISO 100; waterproof camera box + Plexiglass tubes for flashes; Trailmaster 1550-PS remote trigger.

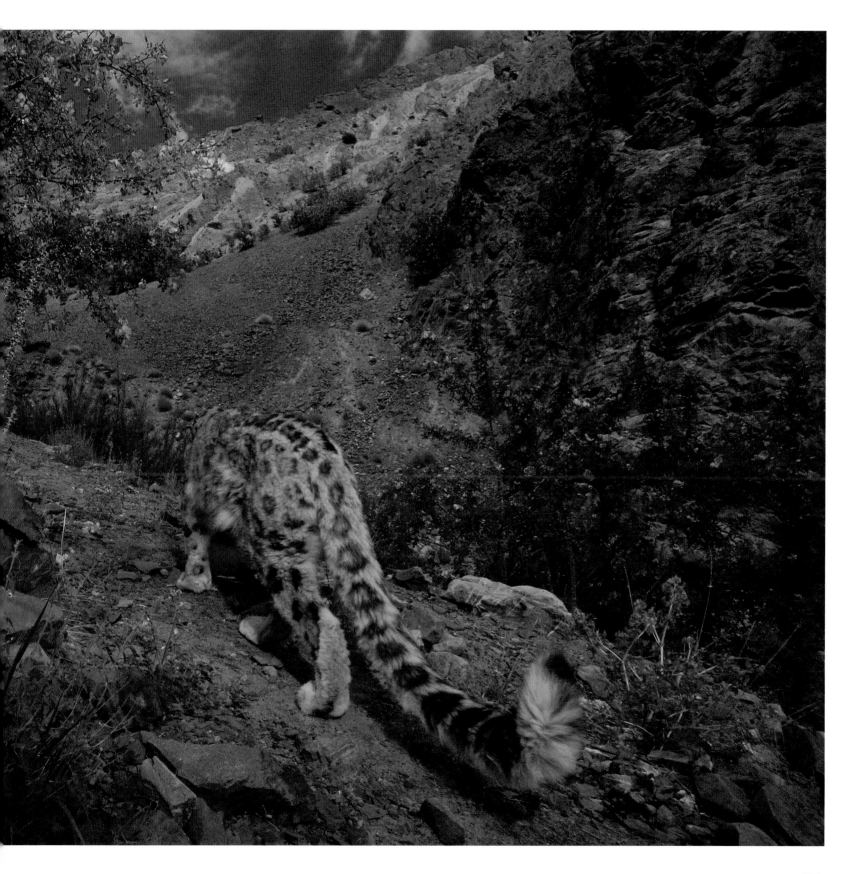

Young Wildlife Photographer
of the Year Award

This award, a cash prize and the title Young Wildlife Photographer of the Year 2008 goes to Catriona Parfitt – the young photographer whose image has been judged to be the most memorable of all the pictures by young photographers aged 17 or under.

Catriona Parfitt

Since Catriona was given her first camera at the age of five, she has been a keen photographer, of landscapes as well as wildlife. Her family enjoys wildlife holidays, which has given her time to concentrate on her photography. Art and music are her other great loves – and horses. This was the first time she has entered the competition, and, at 15, winning the award has given her the confidence to follow her dream of becoming a wildlife photographer or film-maker.

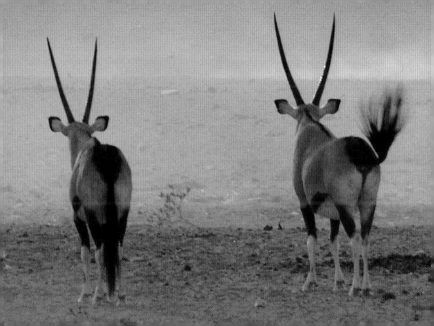

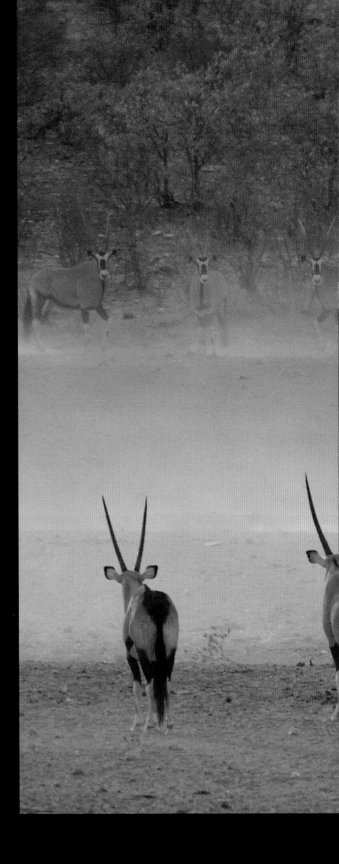

The show

WINNER

Catriona Parfitt

UNITED KINGDOM

No lion in its right mind would dare to attack
a grown giraffe: a well-placed kick from one of
those long legs could be fatal. Yet as Catriona and
assembled gemsbok watched one evening near
a waterhole at Hobatere Lodge in Damaraland,
Namibia, this young male lion repeatedly harassed
the thirsty giraffe. 'When the giraffe first arrived,
it was very nervous,' says Catriona. 'As it walked
slowly towards the water, it kept looking over its
shoulder towards the ridge where it knew there
was a pride of four lions.' Perhaps a twitchy,
solitary giraffe was just too much of a temptation
for a bored lion, because every time the giraffe
got anywhere near the water, the lion loped down
and chased it away. It was, says Catriona, 'just
toying with it'. So the lion got its entertainment,
and the giraffe never did manage to drink.

Canon EOS 400D + Canon EF300mm f4 IS USM lens
+ Canon EF 1.4 extender; 1/200 sec at f5.6; ISO 100.

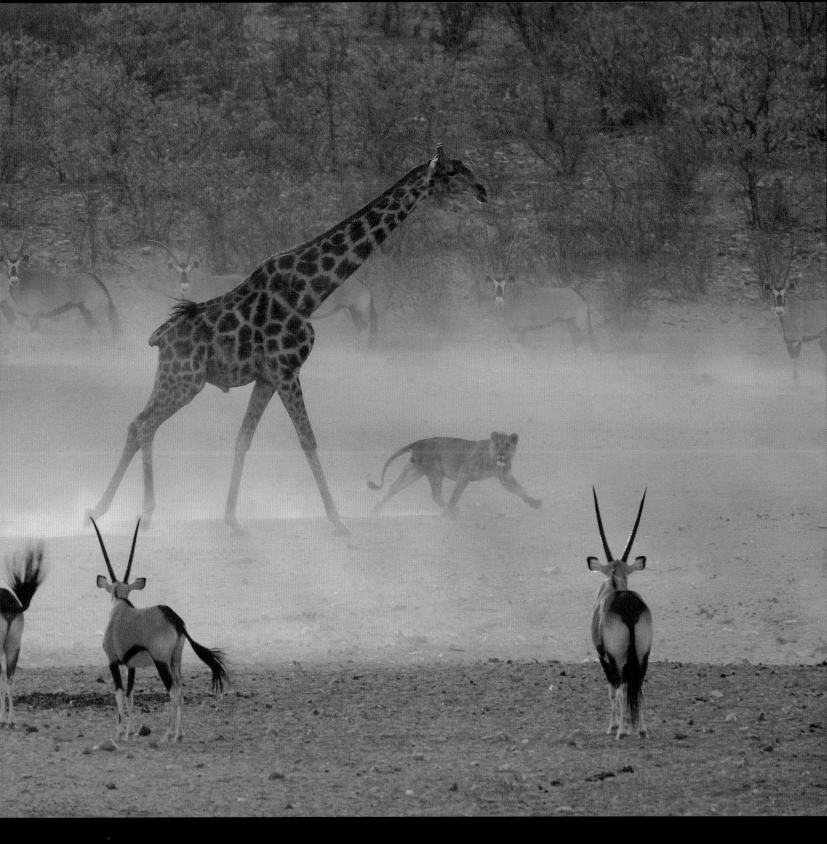

Battle of the bears

SPECIALLY COMMENDED

Tom Mills

UNITED KINGDOM

The scene took place at midnight on pack ice in Spitsbergen, Norway. Three huge males were tearing into a bearded seal carcass, watched from nearby ice by a female with a young cub. Obviously starving, the female dived into the water, 'leaving her cub screaming and yelping', says Tom. 'It was so distressed.' Snarling, she managed to drive off the males and feed for a few seconds. But one male now had its sights on the cub. As it hauled up on ice near the cub, the cub leapt into the water, its frantic cries bringing its mother to the rescue.

Nikon D70 + Tamron 70-300mm lens at 300mm; 1/320 sec at f6.3.

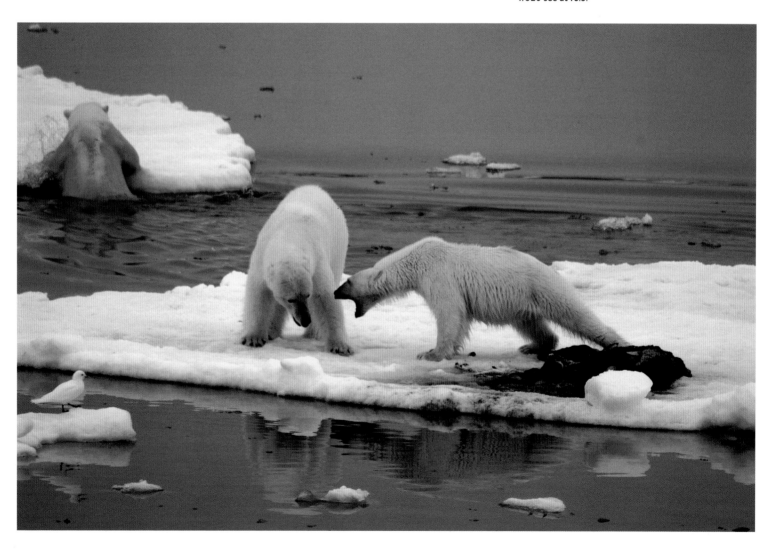

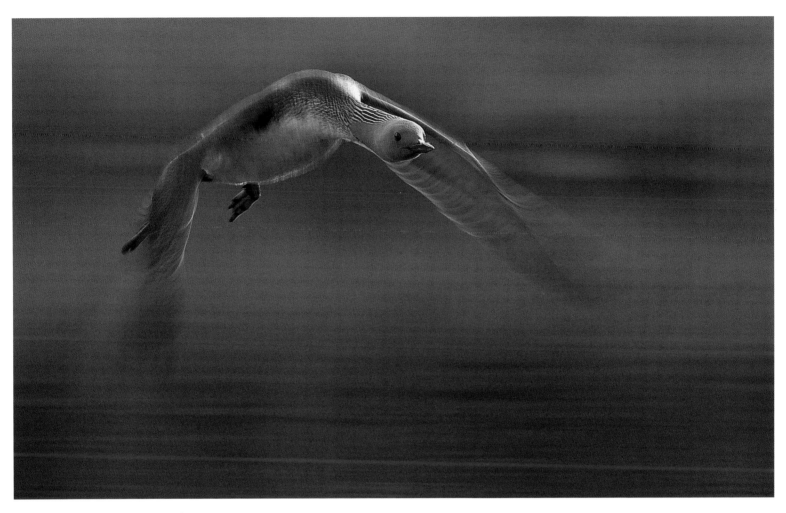

Diver lift-off

RUNNER-UP

Mathias Blix

NORWAY

Mathias went on a photo safari to Sweden specifically to photograph divers. The location for his winning shot – a small lake near Surahammar in southern Sweden – was ideal, as the birds were used to people, which meant Mathias didn't need a hide. His chance to get a more unusual shot came when he saw this red-throated diver about to take off. Being such a heavy bird, it needed lots of space to get airborne, giving Mathias a few seconds to prepare. 'As the diver picked up speed,' he says, 'I tracked it, wanting to keep the blur of wings to show the sheer energy required to lift the bird off the water, but taking care to keep its head in focus.'

Nikon D200 + 200-400mm f4 VR lens at 380mm; 1/60 sec at f6.3; ISO 200.

Last breath of autumn

HIGHLY COMMENDED

Michal Budzyński

POLAND

A sudden heavy snowstorm took Michal and his friends by surprise. It was autumn, and they had come for the weekend to the Pieniny Mountains in southern Poland to photograph the famous autumn colours of firs, beeches, larch and spruce. The first day was bright and sunny, perfect for photographing the dazzlingly fiery landscape. Overnight, though, snow extinguished the glow, and the weather stayed cold and dull until the friends set off to go home. As they drove down the mountain, Michal looked back and glimpsed in the distance a single glowing patch of gold. 'For some reason the snow must have slid off the branches of the beech trees but stuck to the firs,' he says, 'creating the breathtaking view.'

Nikon D80 + Nikkor 300-400mm lens; 1/400 sec at f5.6; ISO 125.

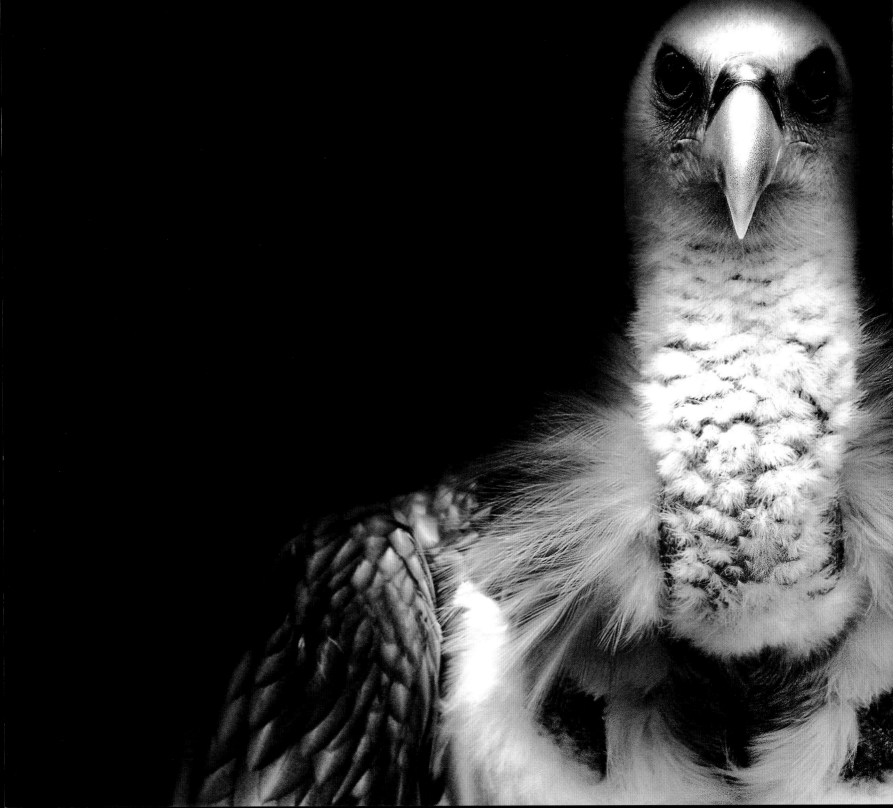

Night griffon

HIGHLY COMMENDED

Safie Al Khaffaf

RUSSIA

At dusk, Safie's natural-history group set up camp near the Kirtik river, on the Russian side of the Caucasus mountain range. As darkness fell, Safie set off to look for insects to photograph. Searching some rocks with her torch, she suddenly realized that she had illuminated a pair of eyes. Just metres away, staring back at her from its perch, was a griffon vulture. 'I was shocked – and impressed by the striking beauty of the bird,' she says. Safie quickly took control of the situation and shot two portraits. The opportunity was fleeting. The vulture hissed loudly, launched off and flapped into the night.

Nikon D70; 200mm lens; 1/60 sec at f6.7; ISO 200; Nikon speedlight SB-800.

Deer magic

WINNER

Jean de Falandre

FRANCE

Sologne is a huge wild area south of Paris, once
full of hunting reserves. On early mornings,
a misty magic descends over the forests, lakes,
heaths and marshes. Wild boar, foxes and red deer
are abundant. This is where Jean spends much of
his time, photographing wild animals – his
passion. In the autumn school holiday, he worked
out the best place to watch the red deer – beside
a clearing that deer had to cross to reach the
woods on the other side – and stationed himself
there, downwind, early in the morning. When this
doe and fawn arrived a few hours later, 'the light
was good,' he says, 'but the difficulty was
selecting the right shutter speed, because the deer
move so fast.' That he succeeded in getting the
shot he wanted was the result of careful planning

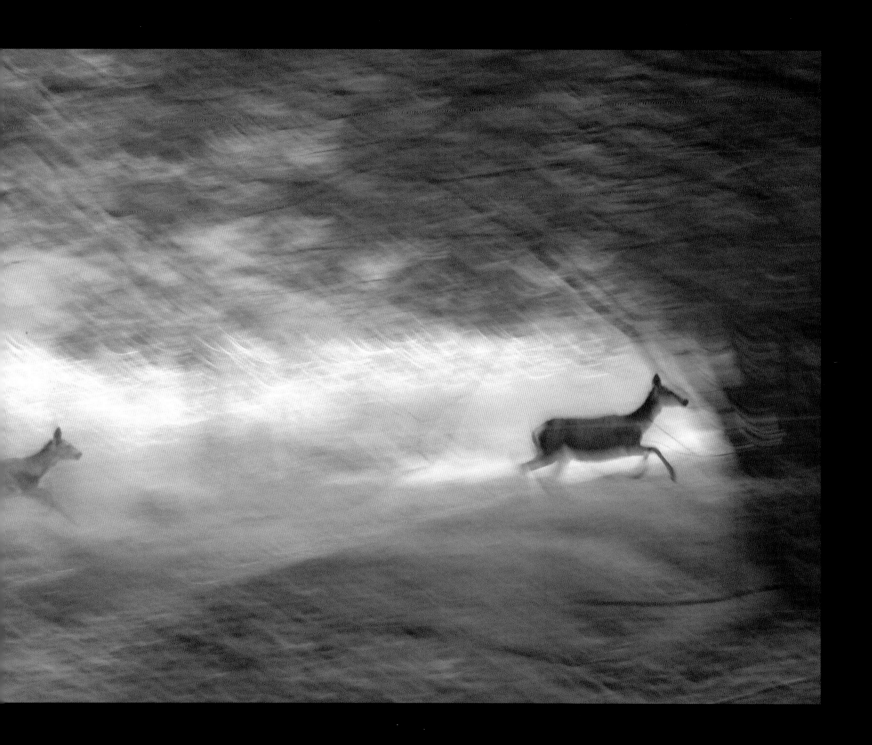

Whooper delight

RUNNER-UP

Jesse Heikkinen

FINLAND

As the snow started to fall, the whooper swans 'got all crazy' and their strident whoop-whoop honks filled the air. Jesse had spent the afternoon photographing them from a hide in Kuusamo, Finland, with professional wildlife photographer Hannu Hautala. It was part of his prize for being awarded the title of Young Wildlife Photographer of the Year 2005, two years before, when he was just 10. The session began in bright sunlight, with the swans going about their usual business, quietly. Then suddenly everything changed – the scene became wintry and 'the swans became bewitched by the frisky snow,' says Jesse. 'They started shouting.' And he started shooting.

Nikon D70 + Sigma 120-300mm f2.8 lens; 1/50 sec at f5.6; ISO 200.

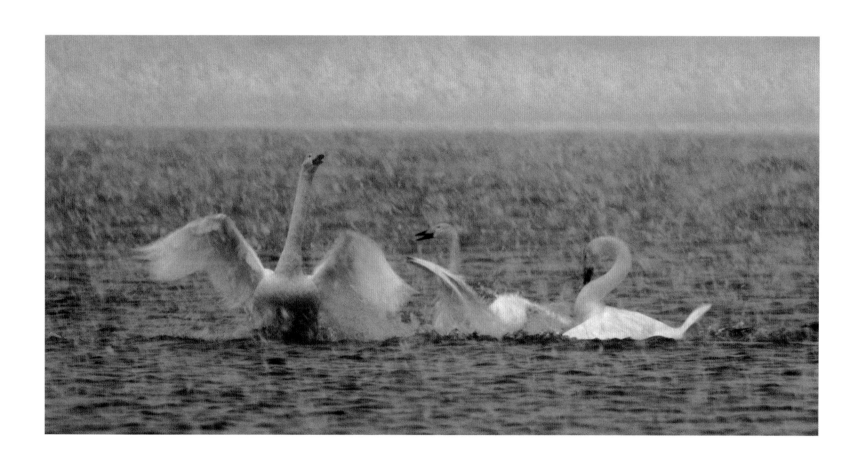

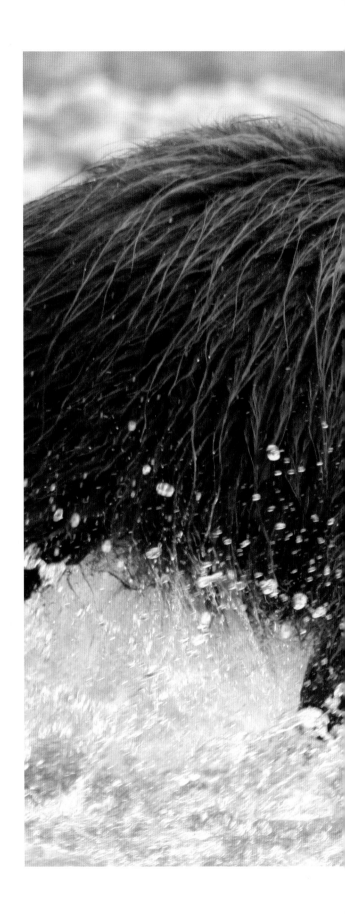

Grizzly leap

SPECIALLY COMMENDED

Caroline Christmann

USA

'Keep absolutely still, sweetie, or you may trigger the kill instinct.' It's not the advice most fathers need to give. But then most daughters don't kneel on a riverbank with nothing but 10 metres of Alaskan soil separating them from a 600kg grizzly. Caroline was with members of her family in the remote Geographic Harbor in Katmai National Park photographing grizzly bears fishing for salmon. This grizzly, she says, was 'focused, determined and patient'. She snapped him moments before he pounced with 'an incredible explosion of energy', skilfully trapping a salmon under his massive paws. He carried the fish to the bank and ripped its head off with a crunching pop, the breeze wafting his wet-old-dog scent over her. Caroline managed to stay still and keep her camera steady. She saved the shaking for later.

Canon EOS Rebel XT + 300mm zoom lens; 1/400 sec at f7; ISO 1000.

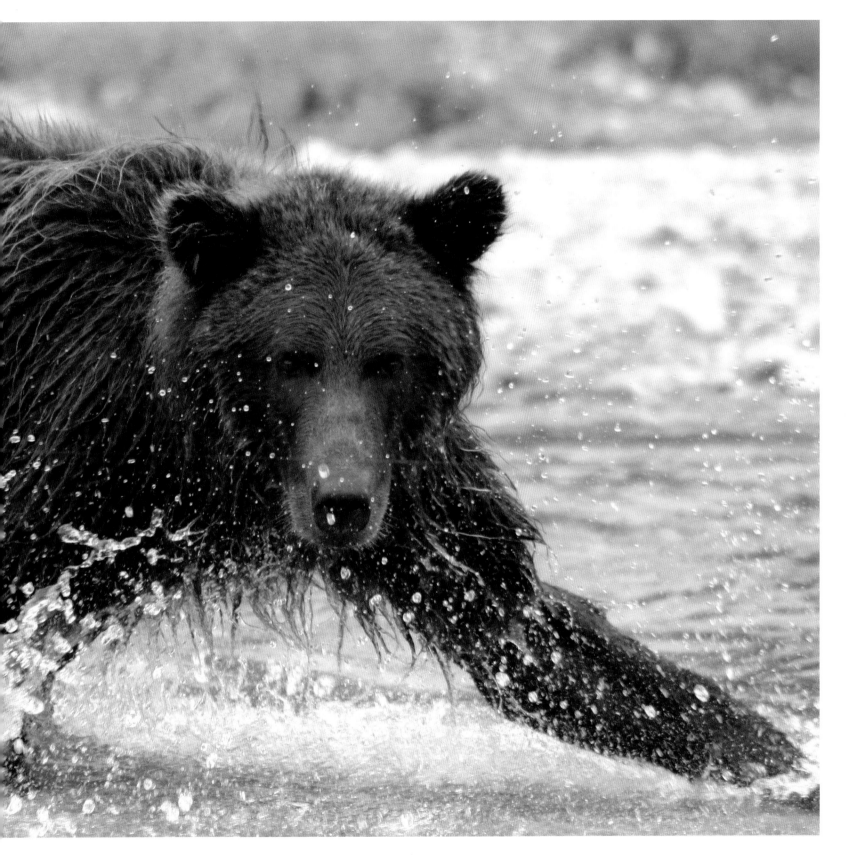

What's up?

HIGHLY COMMENDED

Julian Das

UNITED KINGDOM

'We spent three days at Savuti Camp in the Okavango,' says Julian, 'where we were lucky enough to see a pride of eight lions – three males and five lionesses.' They had just eaten and were stretched out around a tree in a relaxed and playful mood. One of the young males climbed a low-hanging bough and started walking about on it. Curiosity then got the better of him, and he decided 'to watch me through a v-shaped gap between the two trunks of the tree,' which is when Julian took his shot. 'It was really funny seeing a lion behaving like this in a tree,' he adds.

Canon EOS Rebel XT + Tamron 75-300mm lens at 200mm; 1/200 sec at f5; ISO 100.

White on blue

SPECIALLY COMMENDED

Martin Gregus

SLOVAKIA/CANADA

Martin often goes to a quay near where he lives in Vancouver, Canada, to take photographs of cruise ships and birds. After many weeks of constant rain, it was a relief to head out on a cold, sunny day. The herring gulls obviously thought so, too, because they seemed more animated than usual. Though his mother was keen to go home, out of the cold, Martin hung on to take shots of the gulls. 'I like the sharp, contrasting colours of this shot,' says Martin, 'and the way the pristine white tail feathers fan out against the bright light.'

Nikon D70 + 80-400mm f4.5-5.6 AF VR Nikkor lens at 300mm; 1/2000 sec at f5.6; ISO 200.

Eye to eye

HIGHLY COMMENDED

Franklin Ramirez

HONDURAS

'Off you go!' said Franklin's photography-club
teacher as he sent his young pupils outside to
practise their newly learned skills. Clutching his
camera, Franklin wandered behind the building in
Las Mangas, Honduras. His teacher had told them
about vine snakes, which often hang around here.
So when he spotted this one, so slender and light
that it seemed almost to float across the tangle
of vines growing up through the fences, he knew
it wouldn't harm him and decided to go for
a close-up, using the macro setting on his camera.
The delicate snake, also called a blunt-headed
tree-snake, feeds mostly on insects, and it blended
in perfectly with the vine stems.

Canon Powershot A610; 1/200 sec at f2.8.

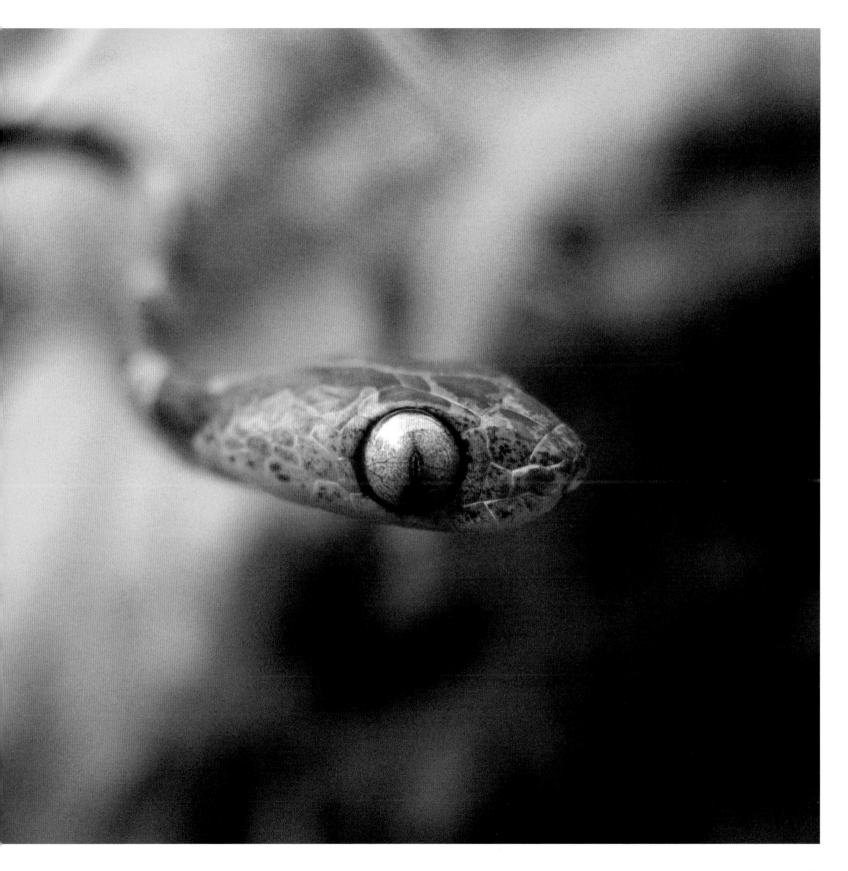

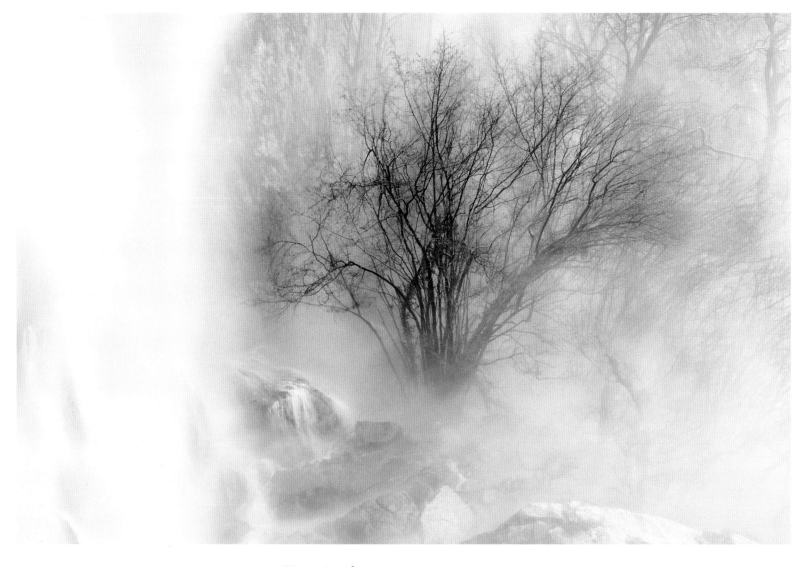

Tree in the mist

HIGHLY COMMENDED

Nilo Merino Recalde

SPAIN

Exploring the source of the River Asón in Cantabria, where he lives, Nilo discovered this waterfall. Beneath the falls, clinging precariously to the rocks, was a tree with a spray of golden branches. The dull February light, fog and mist from the water added mystery to the scene. Scrambling down to get close to the waterfall, Nilo became immersed in the experience. 'Water splashed all over my equipment,' he says, 'and I ended up soaked.'

Olympus E-500 + 14-54mm f3.5-5.6 Zuiko lens at 35mm; 1/15 sec at f10; ISO 100; circular polarizer filter; tripod.

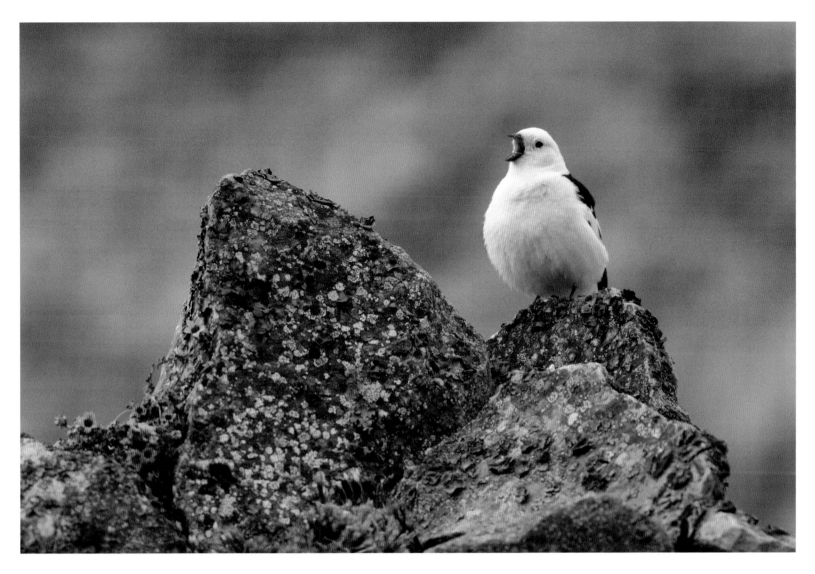

Snow bunting songster

HIGHLY COMMENDED

Johan Gehrisch

SWEDEN

This snow bunting is clearly defending his territory with passion. Johan spent days photographing the buntings behind the hotel on Svalbard where his family were staying. As this male made its territorial rounds, Johan sat waiting, knowing the bird would return to its song-perch rock. 'I waited for more than three hours on two different days,' Johan says, 'and the bunting returned several times to the rock, each time giving a flawless performance.'

Canon EOS 20D + 400mm f5.6 lens; 1/1600 sec at f5.6; ISO 400.

Snow pose

Great tits and teasels

RUNNER-UP

Baptiste Drouet

FRANCE

A keen nature-watcher, Baptiste spends a lot of time observing the birds around his home in La Chapelle Saint Florent, France. One cold winter morning, he noticed great tits feeding on teasels and thought it would make a good shot. Sticking shelled sunflower seeds into the teasel heads to keep the birds busy, he asked his father to set up his camera on a tripod for him, while he stayed hidden behind the kitchen window that he had meticulously cleaned. As he left, his father gave Baptiste his professional advice: 'Be patient, and when you see something you like, press the shutter.' Baptiste spent the whole afternoon pressing the shutter, stopping only when dusk fell and there were no more birds to photograph.

Canon EOS 350D + Canon 70-200mm lens; 1/1400 sec at f5.6; ISO 200; Manfrotto tripod.

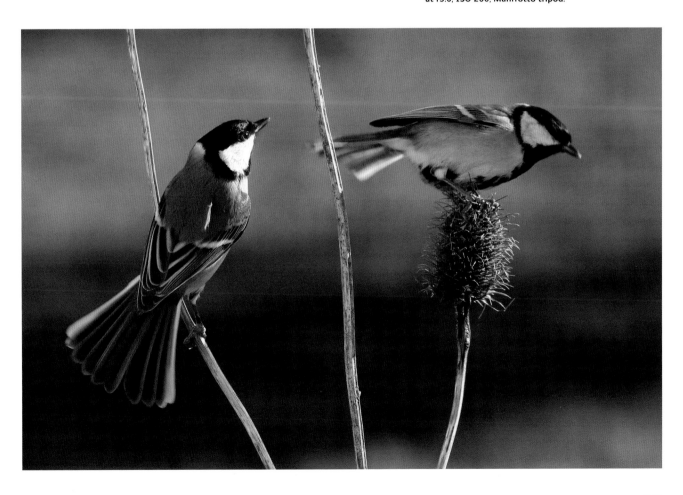

Gull perfection

HIGHLY COMMENDED

Mimmi Widstrand

SWEDEN

While everyone else on the boat concentrated on photographing sea eagles, Mimmi focused on other potential subjects overhead – screaming, scavenging, scrapping gulls. She was with her family on a sea-eagle safari in Flatanger on the Norwegian west coast. The skipper was hurling fish into the sea. Local sea eagles, recognizing his boat, were flying in to feed – majestic, graceful silent and invited – unlike the rowdy gate-crashing herring gulls. While the gulls snatched fish, Mimmi snatched an opportunity.

Nikon D2xs + 70-200mm f2.8 VR Nikkor lens; 1/1250 sec at f5 (-1 compensation); ISO 200.

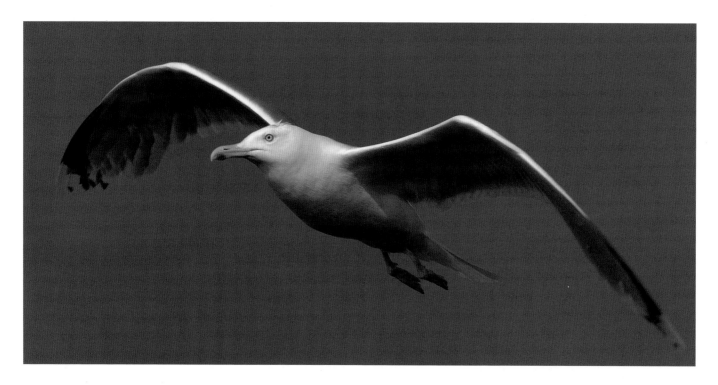

Treetop jigsaw

HIGHLY COMMENDED

Brittany Fried

USA

When visiting Malayia, Brittany was captivated by a walk through the rainforest. She craned to look at the canopy, which was like a roof over the entire forest. 'I found it intriguing', she says, 'that something as simple as treetops could look as beautiful as these did.' They slotted together in a way that reminded her of a jigsaw. 'I love nature,' she says, 'and the thought of a giant puzzle made me think how amazing the Earth is and how small humans are.'

Nikon Coolpix S9.

Index of photographers

138
Safie Al Khaffaf (Russia)
aku-safi@rambler.ru

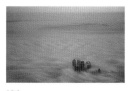

135
Mathias Blix (Norway)
mathias@blixfoto.com
www.blixfoto.com

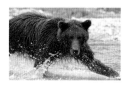

121
Piers Calvert (UK)
piers@pierscalvert.com
www.pierscalvert.com

144
Caroline Christmann (USA)
john.christmann@apachecorp.com

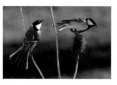

120
Martijn de Jonge (The Netherlands)
mrjonge@xs4all.nl
www.martijndejonge.nl

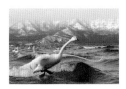

56
Ellen Anon (USA)
ellenanon@mac.com
www.ellenanon.com

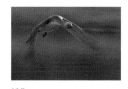

98
Carsten Braun (Germany)
carsten.braun@web.de
www.braun-naturfoto.de

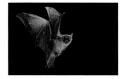

38
Patrick Centurioni (Austria)
patrick.centurioni@gmx.at
www.centurioni.com

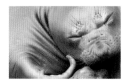

104
Claudio Contreras Koob (Mexico)
cckoob@yahoo.com
www.claudiocontreras.com

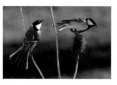

153
Baptiste Drouet (France)
domdelaloge@wanadoo.fr

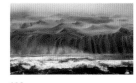

108
Andy Biggs (USA)
andybiggs@gmail.com
www.andybiggs.com

136
Michal Budzynski (Poland)
michal.fp@gmail.com
www.mbudzynski.art.pl

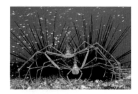

146
Julian Das (UK)
julian_the_beast12@hotmail.co.uk

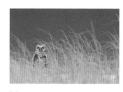

96
Adriano Ebenriter (Brazil)
ebenriter@hotmail.com

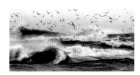

48
Guillaume Bily (France)
guillaume.bily@wanadoo.fr

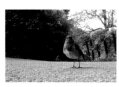

102
Andreas Byrne (UK)
apjsbyrne@hotmail.com

82, 95
Jordi Chias (Spain)
jordi@uwaterphoto.com
www.uwaterphoto.com

140
Jean de Falandre (France)
defalandre@wanadoo.fr

68
Fredrik Ehrenström (Sweden)
aqua.media@telia.com
Agents
ww3.osf.co.uk
www.naturfotograferna.se/index.html

66
Cece Fabbro (USA)
cecefab@aol.com
www.cecefabbrophoto.com

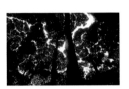

155
Brittany Fried (USA)
brittanylfried@gmail.com

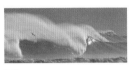

112
Albert Froneman (South Africa)
albert@wildlifephotography.co.za
www.wildlifephotography.co.za

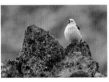

151
Johan Gehrisch (Sweden)
birdwatcher93@hotmail.com

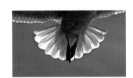

147
Martin Gregus (Slovakia/Canada)
matkojr@shaw.ca
www.matkopictures.com

88
David Hall (USA)
david@seaphotos.com
www.seaphotos.com

94
Bill Harbin (USA)
wpharb@comcast.net

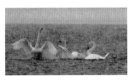

142
Jesse Heikkinen (Finland)
jari.heikkinen@ppq.inet.fi

44
Adrian Hepworth (UK)
adrian@hepworthimages.com
www.hepworthimages.com
Agent
www.photoshot.com

99
Juan Manuel Hernández López
(Spain)
luluson@teleline.es
www.juanmanuelhernandez.com

24
Paul Hobson (UK)
paul.hobson6@virgin.net
www.paulhobson.co.uk
Agents
www.naturepl.com
www.flpa-images.co.uk

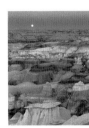

20
Antoni Kasprzak (Poland)
huczek-ad@wp.pl

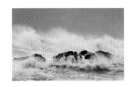

49
Fergus Kennedy (UK)
fergus@adelphi-env.com
www.ferguskennedy.com

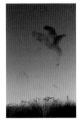

33
Barış Koca (Turkey)
bariskoca@hotmail.com
www.bariskoca.com

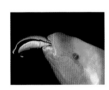

90
Noam Kortler (Israel)
nemodive@netvision.net.il
www.nemodivers.co.il

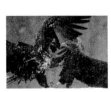

110
Franz Josef Kovacs (Austria)
franz.kovacs@direkt.at
www.kovacs-images.com

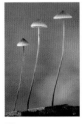

54
Michael Lambie (Canada)
mlambie@soundquest.ca

75
Danny Laps (Belgium)
dannylaps@skynet.be
www.dannylaps.net

16
Miguel Lasa (UK/Spain)
miguel.lasa@btinternet.com
www.miguellasa.com

Index of photographers

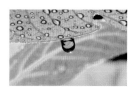

74
Darran Leal (Australia)
darran@wildvisions.com.au
www.wildvisions.com.au

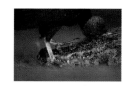

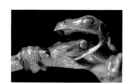

40, 116
David Maitland (UK)
dpmaitland@googlemail.com
www.davidmaitland.com

26
Bence Máté (Hungary)
bence@matebence.hu
www.matebence.hu

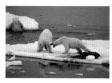

22
Brian W. Matthews (UK)
brian@bwmphoto.com
www.bwmphoto.com

60
Dan Mead (USA)
dansal@mac.com
www.meadeaglephotos.com

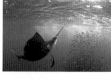

150
Nilo Merino Recalde (Spain)
nilo@nilomerinorecalde.com
www.nilomerinorecalde.com

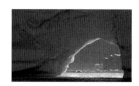

118
Ira Meyer (USA)
ira@irameyer.com
www.irameyer.com

134
Tom Mills (UK)
thomas_mills373@hotmail.com

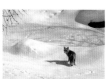

30
Arthur Morris (USA)
birdsasart@att.net
www.birdsasart.com

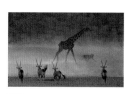

42, 89
Amos Nachoum (Israel/USA)
amos@biganimals.com
www.biganimals.com

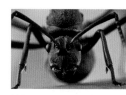

100
Piotr Naskrecki (Poland)
p.naskrecki@conservation.org
www.insectphotography.com
Agent
www.mindenpictures.com

32
Ramón Navarro (Spain)
foto@ramonnavarro.net
www.ramonnavarro.net
Agents
www.fotonatura.com
www.agefotostock.com

152
Alessandro Oggioni (Italy)
roggion1@tin.it

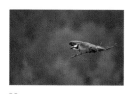

130
Catriona Parfitt (UK)
cool4cat@btinternet.com

84
Thomas P. Peschak (South Africa)
tpeschak@iafrica.com
www.thomaspeschak.com

86
Laurent Piechegut (France)
piechegut.laurent@orange.fr
www.lepeupledeleau.fr

148
Franklin Ramirez (Honduras)
franklin.kikoloco.rivera@gmail.com
www.guaruma.org

18
Michel Roggo (Switzerland)
info@roggo.ch
www.roggo.ch
Agent
www.naturepl.com

28
Andy Rouse (UK)
andy@andyrouse.co.uk
www.andyrouse.co.uk
Agents
www.gettyimages.com
www.corbis.com
www.nhpa.co.uk

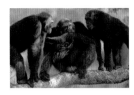

34
Cyril Ruoso (France)
cyril.ruoso@wanadoo.fr
www.ruoso-grundmann.com
Agent
JHEditorial@aol.com

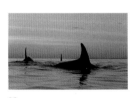

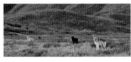

62
Nuno Sá (Portugal)
fotonunosa@gmail.com
www.photonunosa.com

58
Florian Schulz (Germany)
visionsofthewild@yahoo.com
www.visionsofthewild.com

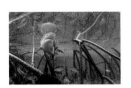

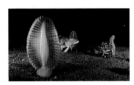

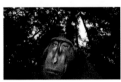

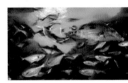

52, 76, 78, 80
Brian Skerry (USA)
brian@brianskerry.com
www.BrianSkerry.com
Agent
www.ngsimages.com

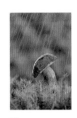

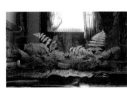

114
Jamie McGregor Smith (UK)
info@jamiemcgregorsmith.com
www.jamiemcgregorsmith.com

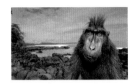

92, 124
Stefano Unterthiner (Italy)
info@stefanounterthiner.com
www.stefanounterthiner.com
Agent
agent@stefanounterthiner.com

69
Thierry Van Baelinghem (France)
naturenimage@gmail.com

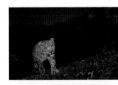

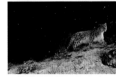

70, 72
Koos van der Lende (South Africa)
koos@delende.com
www.delende.com
Agent
Dominique@delende.com

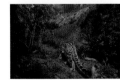

107
Chris van Rooyen (South Africa)
chris@wildlifephotography.co.za
www.wildlifephotography.co.za

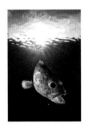

46
Carlos Virgili (Spain)
risck@risck.com
www.risck.com

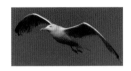

154
Mimmi Widstrand (Sweden)
photo@staffanwidstrand.se

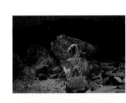

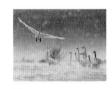

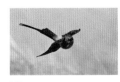

36, 14 & 122, 126, 128
Steve Winter (USA)
stevewinterphoto@mac.com
Agent
www.ngsimages.com
akeating@ngs.org

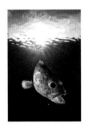

106
Aaron Wong (Singapore)
evid77@yahoo.com
www.aaronsphotocraft.com

50
Yongkang Zhu (China)
zhu_yong_kang@126.com

64
Christian Ziegler (Germany)
zieglerphoto@yahoo.com
www.naturphoto.de
Agent
www.mindenpictures.com

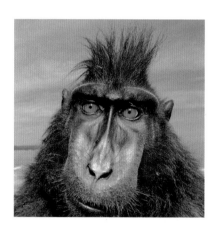